TIME
& MOTION
...
REDEFINING
WORKING
LIFE

Editors
Emily Gee and Jeremy Myerson

Artistic Director
Mike Stubbs

Contents

Foreword
Professor Sir Christopher Frayling

With the spread of digital technology, the working world is currently facing its biggest shake up since the first industrial revolution – and artists and designers have much to offer through their visual and verbal commentaries on the scale of the disruption.

Just as William Morris – the artist craftsman and social campaigner, not the automobile magnate – warned about the wider implications of machinofacture and de-skilling, so this book presents a timely series of polemics and projects from today's art and design community about the dangers inherent in a rapid redefinition of working life which blurs the boundaries of work, rest and play. It used to be joked that 'no-one ever said, as their last words, I wish I'd spent more time at the office'. Now that the office is likely to be at home, or wired into the home, this no longer gets a laugh...

The phrase 'Time & Motion' sums it up well. Time & Motion started life with Frederick Taylor's business efficiency studies, which involved the measurement of rows of identically dressed office clerks with a stopwatch. It is deliberately echoed here by the very different meanings of time and motion involved in much contemporary art practice.

There's an irony in the strict rhythms of scientific management and 'Taylorism' being subverted by creative practitioners who are not simply interested in sabotage or 'breaking the flow' but also in suggesting alternative models. The truth is that, despite the superficial rhetoric of liberation, digital networks afford levels of control and productivity and 'the division of labour' that Taylor could only have dreamt about. It is scary stuff. And unpredicted.

Time & Motion marks a collaboration between FACT Liverpool and the Royal College of Art, whose Creative Exchange project looks at how arts and humanities researchers can work with industry to effect digital innovation. This combination of a dynamic national arts venue working with one of our leading design schools is a ready recipe for provocation and fresh ideas, in a city closely associated with change and innovation in the workplace (for starters, think of Port Sunlight, the Halewood Ford Plant, Oriel Chambers and the Liver Building).

Like Richard Koeck in this volume, I am particularly interested in how mainstream cinema has created enduring images of working lives. From the silents Metropolis (1926) and The Crowd (1928) – where the workplace is presented as 'a machine for working in' – to the future shock movies Bladerunner (1984, directed by RCA graduate Ridley Scott), Brazil (1985) and Minority Report (2002), anxieties about the way things are going have been accompanied by a dark mistrust of the unforeseen consequences, the collateral damage, of science and technology.

A medium which owed its existence to the latest scientific research (chemistry and optics) spent its first century telling audiences that the latest scientific research was likely to end in tears. Time & Motion explains some of the reasons why.

In short, this is not a book you can devour in your lunch break – because, apart from anything else, you probably won't be able to take one. ▋

Christopher Frayling was until recently Rector of the Royal College of Art and Chair of Arts Council England. He is the author of 19 books on art and popular culture and an award-winning broadcaster on radio and television. Professor Emeritus of Cultural History at the RCA, he now works from home.

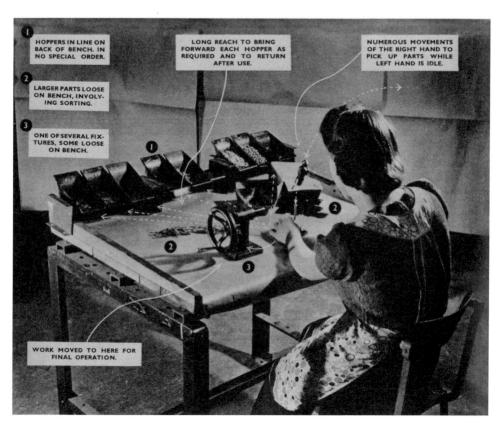

HOPPERS IN LINE ON BACK OF BENCH. IN NO SPECIAL ORDER.

LONG REACH TO BRING FORWARD EACH HOPPER AS REQUIRED AND TO RETURN AFTER USE.

NUMEROUS MOVEMENTS OF THE RIGHT HAND TO PICK UP PARTS WHILE LEFT HAND IS IDLE.

LARGER PARTS LOOSE ON BENCH, INVOLVING SORTING.

ONE OF SEVERAL FIXTURES, SOME LOOSE ON BENCH.

WORK MOVED TO HERE FOR FINAL OPERATION.

Time and Motion Study, IPC Magazines/Picture Post Courtesy of Getty Images

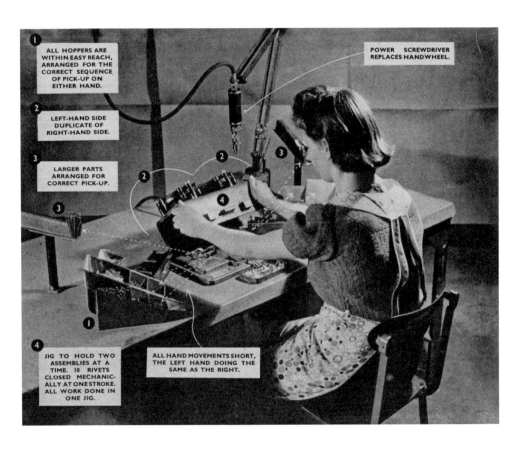

Introduction
Emily Gee and Jeremy Myerson

This anthology of essays, artworks and design experiments looks at the effects of digital technology on patterns of working life – and at how artists and designers are creatively interpreting the new realities of an increasingly distributed and globalised working world in which the traditional eight-hour working day is fast losing its relevance. Published to coincide with the *Time & Motion* exhibition and public programme at FACT (Foundation for Art and Creative Technology) in Liverpool[1], this book is a collaboration between FACT and the Creative Exchange at the Royal College of Art.

The subject matter it addresses is rarely out of the news these days, as working life is turned on its head by powerful new forces of digital change. In the UK, as elsewhere, we are now living in a world in which most people are either available all hours and over-worked or under-employed and forced to endure precarious part-time working and zero hours contracts. As Ana Coote explains,

> In this post-industrial era of instant communications, mobile technologies, and global reaches across multiple time-zones, people can increasingly work anywhere, anytime. The logic of a nine-to-five routine for five days a week is out of step. But the new era carries new risks of exploitation, as well as exclusions and inequalities: there is no end to what employers can demand, and no end to what is demanded of our unpaid time as we play our pivotal role in the consumer economy[2].

At a time of structural changes in the labour market, rising youth unemployment and sharp transitions in business practice to address global recession, the subject of rethinking working life in the digital age is both relevant and timely. What makes *Time & Motion* distinctive is the premium it places on the interventions of artists and designers in this debate. As Mike Stubbs, director of FACT and a prime mover in

developing *Time & Motion*, explains, 'Artists naturally reference the world around them with the materials and media of the day, and they are now inevitably reflecting, analysing and subverting our current rhythms, economies and dilemmas in chasing a "perfect" work life balance.'

Artists and designers including Revital Cohen and Tuur Van Balen, Harun Farocki, Blake Fall-Conroy, Electroboutique, Sam Meech and Molleindustria feature in the *Time & Motion* exhibition precisely because their work has something important to say about changing patterns of work; their projects reflect, analyse and subvert our awareness of the switch from the industrial age to an information-rich knowledge economy. From the 'infomania' of constant connectivity through to the possibilities of maker culture, these artists examine and play upon the very technologies that are shaping this shift.

For Stubbs, the whole *Time & Motion* programme can be traced back, not just to those studies perfected in the name of business efficiency by the puritanical engineer Frederick Taylor in the factories and offices of the early twentieth century, but even to the dawn of the eight-hour working day. Indeed he cites the Monument to the Eight Hour Day built opposite Trades Hall in Melbourne in 1856 as one of his main inspirations for the entire project.

During the Industrial Revolution, workers fought for the right to a work-life balance in which they could perform their eight hours of labour and then leave through the factory gates. Founder of the eight-hour movement in the UK, Robert Owen, coined the famous idiom 'Eight hours labour, eight hours recreation, eight hours rest' in 1817 and this became the standard division of the workers' daily life. As Owen wrote,

> Eight hours daily labour is enough for any human being, and under proper arrangements sufficient to afford an ample supply of food, raiment and shelter, or the necessaries and comforts of life, and for the remainder of his time, every person is entitled to education, recreation and sleep.[3]

But whereas the physical labourer traditionally performed their work over the allotted eight-hour timeframe, protected by the pioneering legacy of Owen and his peers, the information worker's time today is fragmented and variable, and enjoys no such temporal protection. In the workplaces of pre-Internet technologies, the average workday ended when the factory gates or office doors closed. The contemporary information worker labours within a 'factory' whose gates never

close and with work continuously, tantalisingly close to hand right round the clock. This is the central dilemma that *Time & Motion* seeks to investigate.

For Mike Stubbs's main collaborator on the project, Jeremy Myerson of the Royal College of Art, the siting of *Time & Motion* in Liverpool is as significant as any reference to the campaign for an eight-hour working day. Myerson was born and grew up in the city where Stubbs now revels in leading FACT, a national centre built on the foundations of new media thinking and a hub where art, creativity and people meet, both in physical space and increasingly in the digital realm. Liverpool and *Time & Motion* are, in Myerson's view, Taylor-made for each other.

This is a city built on the traditional patterns of industrial working and masculine graft that is now fast reinventing itself for the twenty-first century; a city that has both shaped and been shaped by its labour. From its origins as a 'pool of life', as a natural harbour, through to being a hub of international trade and exchange during the Industrial Revolution, Liverpool inspired numerous 'world firsts', such as the first inter-urban rail link to another city (the Liverpool and Manchester Railway, 1830), the first fully electrically powered overhead railway (the Liverpool Overhead Railway, 1893) and, away from the world of industry and towards the realm of the office worker, the first building featuring a metal-framed glass curtain wall and a modular workspace interior (Oriel Chambers, 1864).

Dock-based work died out in this city in the 1970s as containerisation (roboticisation) took work from the hands of men to the control of programming. Today new forms of casual labour challenge traditional thinking on continuous employment, regular income and the mobility of workforces. The city's current crop of co-working spaces, hack labs and places to foster entrepreneurship shows that, once again, Liverpool readapts.

Time & Motion's rich mix of research, interaction and engaged provocation simply adds to the texture and interrogates the shift. Mike Stubbs's focus at FACT on the ability of contemporary art to ask the urgent questions about the undermining of some of our most basic rights is matched here by Myerson's interest (as a co-investigator on the Creative Exchange project) in the ability of design to reveal our hidden working systems of power, exchange and value. The Creative Exchange at the Royal College of Art is a knowledge exchange hub that seeks to expand the creative economy in the UK by bringing artists, designers, researchers, academics and industry partners together in new creative collaborations.

As a companion reader, this anthology is organised in three main sections – Labour, Representation and Space – using essays by leading commentators on art,

design and digital labour, alongside artworks, contextual and archival materials and current research-led projects. The Labour strand is opened by Georgina Voss, who re-evaluates the hopes and ideals of the 1990s Internet industries; we were to work within a 'weightless economy', unbound by location as our new media clusters created vast networks to engage. Voss questions the current casualisation of digital labour within not only our work but our wider lives, taking us into the world of London volunteers who strap heavy cameras to their bodies to capture, unpaid, the city's canals for Google Street View technology.

Mike Stubbs considers the concept of value and its position within the history of labour. Value is produced through workers' labour and as such the worker has a use value, but where do we place value in the activities that we perform and the units of time that we spend in undertaking them? How is this unit of measurement calibrated and what is it equated against? How do we value our time when we do not act efficiently or productively? Stubbs considers art's relationship with labour and focuses in on the artists who play with the notion of denying and subverting systems of production and value.

The Labour strand is completed by radical game-maker Paolo Pedercini of Molleindustria, who investigates the collapse of what were once distinct domains of work and play in his essay on what might be described as 'playbour'. Computer games, he writes, are the aesthetic form of rationalisation; they mirror capitalism's drive for efficiency and control and so, in our recreation, we act out the productive methods of Taylorism.

In the second section, Representation, a trio of writers explore how artists and filmmakers interpret the world of work. Filmmaker Harun Farocki narrates a history of workers leaving the workplace as characterised through the lens of the camera. Inspired by Auguste and Louis Lumiere's documentation of workers leaving the gates of a factory for photographic goods in Lyon-Montplaisir, Farocki questions film's desire only to capture that which takes place in that part of life where the world of work has been left behind.

Architecture and cinema expert Richard Koeck of the University of Liverpool argues that film has historically been a critical voice of the lives of the working class and that through this representation we are given a very real insight into the social, economic and political climate of the given time and place as well as revealing our hopes and fears for the future world of work.

In her essay 'Mind Over Media', cultural commentator Bronać Ferran reflects on our current high-speed networked, data-rich and decidedly fragmented

contemporary environment and questions how our minds make sense of this situation. Referencing pioneering artworks from when the information age was new, Ferran ultimately points towards artists and designers as those we can rely on to lead the march into making sense of our machine times.

The final section on Space contemplates how digital technologies have made change manifest within our spaces of labour. Jeremy Myerson and Phillip Ross argue that new technologies have always made their presence physically known, from the spinning jenny to the elevator, and that they have been a leading force in the evolution of our workplaces. Digital technology, mobile devices and the ubiquitous network have not only supported flexible working but ultimately put the very existence of the office building into question. With this in mind, what do the workspaces of the future look like, where do they already exist and how should architectural form evolve?

Finally, John Fass and Ben Dalton, two researchers from the Creative Exchange at the RCA, examine the implications of the rise of digital public space for our working lives. As digital technologies produce work that is more fragmented and distributed, and digital and physical spaces become increasingly entwined, how are we adapting to these shifts and is our wellbeing under threat?

Underlying all of the ideas in this book are the evident potentialities and pitfalls of a new fluidity in work, the challenges of adopting new work protocols and developing new systems of learning. The world is becoming 'a non-stop work site or an always-open shopping mall of infinite choice', writes Jonathan Crary in his essay 24/7: Late Capitalism and the Ends of Sleep [4]. How does being continuously connected and available equate with previous histories and rhythms of work?

Twenty years ago, in 1993, the Canadian scholar Derek De Kerckhove wrote, 'It is to designers and artists that more and more people will turn to ask for an intelligible and liveable technological environment; it is designers and artists who they will ask to be comprehensive in their approach to reality' [5]. At a stage when new technology has never been so disruptive to our working lives, Time & Motion provides a platform for thinkers, academics, artists and designers to re-envisage our technological environment and our approach to reality. The stakes really are as high as that. ∎

1 Time & Motion: Redefining Working Life, FACT Liverpool, 12 December 2013 to 9 March 2014.
2 Anna Coote et al., 21 Hours: Why a Shorter Working Week Can Help Us All to Flourish in the 21st Century (London: New Economics Foundation, 2010): 14.
3 Robert Owen, Foundation Axioms of Society for Promoting National Regeneration, in 'Man vs. Machine', Morning Chronicle, 7 December 1833.
4 Jonathan Crary, 24/7: Late Capitalism and the Ends of Sleep (London: Verso, 2013): 17.
5 Design Renaissance: Selected Papers from the International Design Congress, Glasgow, Scotland, ed. Jeremy Myerson (Salisbury: Open Eye, 1994): 156.

Oriel Chambers, Liverpool. Courtesy of Architectural Press Archive / RIBA Library Photographs Collection

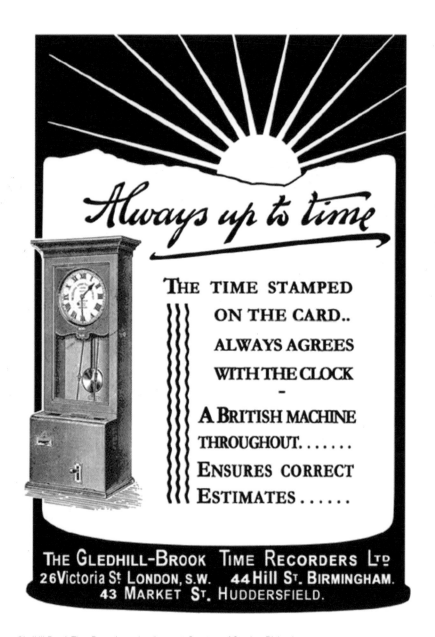

Gledhill-Brook Time Recorders advertisement. Courtesy of Stephen Richardson

Marking Time
Adrian McEwen

Marking Time takes the old-fashioned workers' time clock and remixes it with the suitably retro-mathematical *Game of Life*, created by John Horton Conway in 1970. Creative technologist Adrian McEwen has hacked an antique time clock, introducing the tools of the maker culture within which he works and transforming the time clock from an instrument of strict time management to one of new potential to make and play.

Each day a new game plays out, driven by the punch of the time clock. Some days the *Game of Life* will burn brightly but short; others it will continue for a long and healthy run. The mechanical action of the clock is combined with a modern embedded computer, which drives a nearby monitor to visualise the *Game of Life* grid and move it on a turn every time a timecard is stamped.

Diamandini
Mari Velonaki

Diamandini is a five-year Australia Research Council project between artist Mari Velonaki and roboticists at the Centre for Social Robotics, Australian Centre for Field Robotics, the University of Sydney and the Creative Robotics Lab, and NIEA/COFA at the University of New South Wales.

This project aims to investigate human–robot interactions in order to develop an understanding of the physicality that is possible and acceptable between a human and a robot within a social space. *Diamandini* is an interactive autokinetic artwork that investigates the dialogical possibilities between a robot, in the form of female figurine that can communicate with her audience through the modalities of movement and (at a later stage, 2013–14) touch. *Diamandini*, in this final year of her development, will 'perform' a designated action governed by 'time' during the *Time & Motion* exhibition.

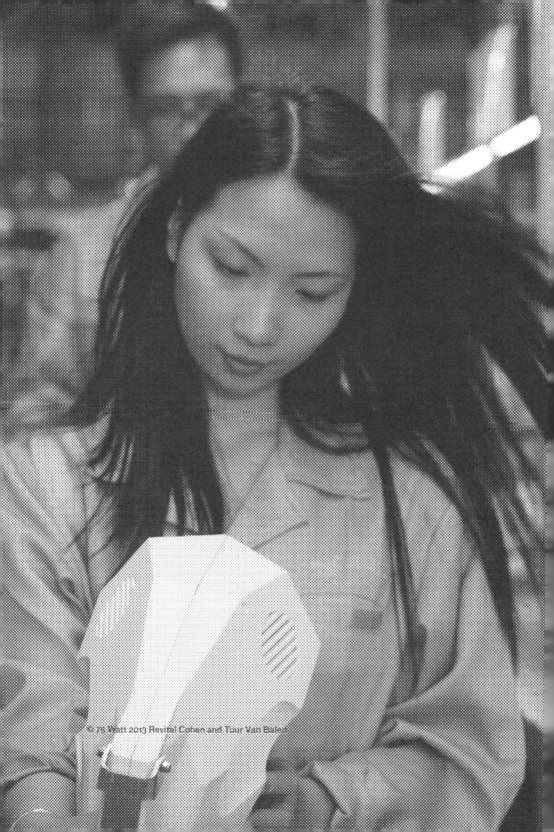

01 LABOUR

DOES

THE

WORKDAY

EIGHT HOUR

STILL EXIST?

Tracks of Digital Labour
Georgina Voss

'The Machine', they exclaimed, 'feeds us and clothes us and houses us; through it we speak to one another, through it we see one another, in it we have our being. The Machine is the friend of ideas and the enemy of superstition: the Machine is omnipotent, eternal; blessed is the Machine.'
E.M. Forster (1909) [1]

In mid-2013, a group of workers split between Florida and London undertook a form of work that would have been inconceivable even five years earlier. By the banks of Regent's Canal and on the shores of Panama City Beach, men and women strapped on a Google Trekker – a large and cumbersome 40-pound backpack topped with an orb bearing a 15-angle lens camera – and set off along the waterways to walk for hundreds of miles, capturing an ongoing series of images. This work contributed to the Google Street View technology, expanding the scope of what could be viewed panoramically on Google Maps to the spaces which could not be easily accessed by motor vehicles but instead needed to be navigated by individuals. Despite being the world's most valuable technology company, compensation for the work was slight – the people walking down Florida's beaches were paid $27 per mile with no extra compensation for accommodation or transport, [2] while those in London were unpaid volunteers from the Canals and Rivers Trust. [3] One of the Florida walkers, Gregg Matthews, said that compensation was not the point of this labour: 'It [the money] is enough to cover expenses but mostly it is fun and probably cheaper than a gym for me.'

Technologies shape, and are shaped by, social change, and this is visibly apparent in the realm of labour. As Vincent Manzerolle states, 'Work under contemporary capitalism is profoundly bound up with the development, deployment and colonisation of everyday life by digital information and communication

technologies.'[4] The impact of ICTs on work under modern capitalism has been extreme, not only creating new forms and ideologies of labour but also raising critical questions about what labour actually is. These technologies are not wholly new: digital computing devices were developed during the Second World War by both German and Allied sides for military ends, with a series of devices being built to support code-breaking activities at Bletchley Park's Government Code and Cypher School. Post-war, the development of transistors and microelectronics improved reliability; costs were reduced; data-processing capabilities increased; and the machines diffused out of the military and into industry.[5] By the mid-1960s, mathematician Norbert Wiener had warned that these responsive machines would intensify the exploitation of workers and replace them altogether.[6] Yet shifts in the mental models around computers reframed the technology as personal, intimate, interactive and even fun, and by the 1980s personal computers were in both homes and offices. Workers – and work – had persisted, but with the emergence of networked technologies, these roles and positions became drastically transformed.

Digitisation is creating massive shifts across aesthetics, audiences, and authorship

Enabled by ICTs, early forms of digital labour spread out across geographic lines. Business was outsourced to telecommuters or distal points on a global production chain coordinated by platform technologies,[7] and as the new media industries emerged in the mid-1990s, speculative claims were made of a future 'weightless economy' in which physical location ceased to be of relevance. In the culture sector, digitisation provided a 'radicalising moment',[8] creating massive shifts across aesthetics, audiences, authorship, regulation and production with new forms of work ushered in, initially for the software developers and digital artists who created the systems upon which the new economies ran.[9] While these workers engaged with digital technologies in the course of their labour practices, the identity of the networked computer as leisure item was also emerging, and the boundaries between the two began to crumble.

Digital technologies had had a personal and personalisable element built into them from the beginning. Jack Good, one of the original scientists and code-breakers at Bletchley Park, described how the machines he'd designed could be modified by users according to their own needs.[10] The development of the BASIC

programming language, which was interactive and easy to write, was also critical in allowing personalised computing to gain a foothold. The Internet further facilitated engagement, embodying an easy-to-join system where anyone with a computer and networked connection could participate. Online spaces allowed people to gather, communicate, share knowledge and content, and also create it. 'User innovation' had been identified by MIT scholar Eric von Hippel[11] in the mid-1970s as a form of practice where skilled users would make or modify their own bespoke products – scientific instruments, sports equipment – rather than buying the products that were already on offer. With the advent of the Internet these practices spread, firstly to the open-software communities, where programmers gathered to develop new forms of open-source software that could be freely developed and distributed without cost.

Drawing on the ethos of earlier hacker culture and Richard Stallman's Free Software movement,[12] the development of open-source software (OSS) was deeply politicised and initially seen as a threat by incumbent software firms. Their perspectives shifted with the realisation that the labour involved in the development of OSS could be seen as a cheap – indeed, possibly free – form of research and development. Influenced by the academic management literature, industry began to explore ways of integrating these external capabilities in-house for their own benefit. Initial strategies were developed to incorporate innovations and modifications from users to feed into internal R&D processes. While these tactics were intended to foster profitable forms of customer participation, not all of the profits were passed back to the users themselves: some were paid for their efforts, but others simply received the warm glow of satisfaction which came from designing their own bespoke product.

These schemes met with variable levels of success in the consumer goods market, but picked up steam in the creative sectors. Digital technologies led to proliferating and widely propagated new forms of amateur and semi-professional content production[13] – blogging, fan-vids, photo-art, music – and new forms of online platforms emerged to host, contain and monetise them. Scholars including Henry Jenkins[14] and Adam Arvidsson[15] describe how this 'participatory culture' which embodies the immaterial labour of cultural consumers has been shoehorned into certain spaces to create and support cultural goods, such as brands. Some of these platforms went from small beginnings to being enormously profitable: YouTube, which was sold to Google for $1.65bn in 2006, and Facebook, which filed a record $5bn initial public offering (IPO) in in 2009.

In the current moment, these participatory platforms are 'simple-to-join, easy-to-play [systems] where the sites and practices of work and play increasingly wield people as a source of economic amelioration by a handful of oligarchic owners'.[16] While terms such as 'prosumer'[17] and 'prosumption'[18] have (re)entered the public domain to describe the reduced distance between production and consumption, delineating the nature of the labour that takes place in such practices has become an increasingly complex undertaking. Scholars have questioned whether it is even possible to consider these activities as labour as it has become increasingly difficult to differentiate between non-productive leisure activities at play and productive activities within the workplace. Similarly, deciding who should get compensated for their work – and how – is no easy task in spaces where the identity of the producer and consumer has collapsed, the line between work and play is fuzzy, and products which were previously sold for remuneration are now offered for free.

Strategies for user-engagement, such as 'crowdsourcing' and 'user-generated content', can be considered a way of putting consumers to work in the culture industries, in a way that liberates repositories of technical, social and cultural competence 'in places previously considered outside the production of monetary value'.[19] In her work on 'free labour', Tiziana Terranova argues that the practices of participating in online discussions, 'modding' software and building websites have constituted 'an important, yet unacknowledged, source of value in capitalist societies'.[20] However, the value of this work has been very specifically named and identified in UK policy reports which flagged how 'proliferating digital technologies mean that we're all potential innovators now. New firms based on user-led innovation are being sold for hundreds of millions of dollars only a few years after being founded'.[21]

The question may not be, Is the value of digital labour acknowledged?, but rather, Who derives value from digital labour, and how? Whether these processes can be deemed exploitative is therefore also under interrogation. Mark Andrejevic has explored how free, affective and immaterial labour, such as that performed on YouTube, can be endowed with autonomy even when it is being freely given.[22] This analysis has been extended by Andrew Ross who argues that while the profits generated by Facebook are derived from the unwaged activities of the site's users, these practices are part of a wider global context where vast amounts of work are done without compensation. Although the Internet itself is mainly created by unpaid labourers rather than employees, David Hesmondhalgh notes that this is not an

unusual quality of the culture industries where most cultural production throughout history has been unpaid. Digital technologies have simply extended many of these features out into wider labour practices by maximising the communicative and cooperative capacity of paid labourers. With the prevalence of smartphones, tablets, personal computers and widespread Internet access, work has become more intensive as workers are expected to accomplish more within the time and space of their working day. Work too has become more extensive, as the integration of ubiquitous media makes it easier to work ever-longer hours. Checking emails on the phone first thing in the morning, on the bus home, last thing at night, all feed what Lise Lareau describes as an 'unlimited capacity for immediacy'.[23] Work has become both ever-present and precarious, with an increase in the contract-based labour workforce which requires workers to be more flexible in their own lives to accommodate changing skills and schedules.[24]

Deciding who should get compensated for their work is no easy task where the identity of producer and consumer have collapsed

Beyond the realm of employees on payroll and contracted freelancers lies the micro-taskforce, the nadir of the contract-worker precariat. In Amazon's Mechanical Turk, gangs of workers gather online to bid to perform tiny tasks such as writing headlines or evaluating whether certain web profiles are of the same individual, for miniscule amounts of payment. TaskRabbit takes these activities offline into the physical world, using online platforms to facilitate the outsourcing of small jobs and tasks to local people willing to don the company's green t-shirt and assemble Ikea furniture. As Scholz highlighted, the micro-taskforce has few if any of the protections which other precarious workers receive – no minimum wage, no health insurance and little intervention from regulators.

And so we return to our Google mappers, offering their services to a massive company who will translate their very physical labour into free digital offerings that could reap enormous financial rewards, none of which appear to trickle back to the men and women with the 40-pound rucksacks on their back. All labour is, ultimately, physical –it involves the material body, whether typing code into a computer or lugging a massive camera down a beach. The transformative impact

of digital technologies on these labour practices has not come about through a technological imposition onto a passive world, but through the world into which they have emerged. Long-standing features of the media and culture industries – casualisation, precarity, exploitation and spillover between 'work' and 'play' – have coloured wider working practices through the new platforms, products and modes of communication and surveillance afforded by digital technologies. As Marx noted, technologies are not themselves the weapons of class war which control and deskill workers but that they also carry the potential to socialise production and do away with wage labour itself – whether they do so depends wholly on the context in which they are developed and deployed.[25] ▌

1 Edward Morgan Forster, 'The Machine Stops', *The Oxford and Cambridge Review* (1909).
2 Associated Press, 'Google Maps Florida's Beaches', HeraldNet, 15 August 2013, www.heraldnet.com/article/20130815/BIZ/708159962 (accessed 30 August 2013).
3 James Vincent, 'From Everest to Stoke Bruerne: Google's Street View backpack hits the UK', *The Independent*, 15 August 2013, www.independent.co.uk/life-style/gadgets-and-tech (accessed 30 August 2013).
4 Vincent Manzerolle, 'Mobilizing the Audience Commodity: Digital Labour in a Wireless World', *Ephemera* 10.3/4 (2010): 455.
5 Jan De Ende and Rene Kemp, 'Technological Transformations in History: How the Computer Regime Grew out of Existing Computing Regimes', *Research Policy* 28.8 (1999): 833–51.
6 Trebor Scholz, 'Why Does Digital Labour Matter Now?', in *Digital Labour: The Internet as Playground and Factory*, ed. Trebor Scholz (London: Routledge, 2010): 2.
7 Andrew Ross, 'In Search of the Lost Paycheck', in *Digital Labour: The Internet as Playground and Factory*, ed. Trebor Scholz (London: Routledge, 2010): 20.
8 Jonathan Burston, Nick Dyer-Witheford and Alison Hearn, 'Digital Labour: Workers, Authors, Citizens', *Ephemera* 10.3/4 (2010): 214–21.
9 Andy Pratt, 'New Media, the New Economy and New Spaces', *Geoforum* 4.1 (2000): 425–36.
10 John Lee and Golde Holtzman, '50 Years after Breaking the Codes: Interviews with Two of the Bletchley Park Scientists', *IEEE Annals of the History of Computing* 17.1 (1995): 32–43.
11 Eric von Hippel, 'The Dominant Role of Users in the Scientific Instrument Innovation Process', *Research Policy* 5.3 (1976): 212–39.
12 Richard Stallman, *Free Software, Free Society: Selected Essays of Richard M Stallman* (Boston, MA: GNU Press, 2010).
13 David Hesmondhalgh, 'User-generated Content, Free Labour and the Cultural Industries', *Ephemera* 10.3/4 (2010).
14 Henry Jenkins, *Fans, Bloggers and Gamers: Exploring Participatory Culture* (New York: New York University Press, 2006).
15 Adam Arviddson, 'Brands: A Critical Perspective', *Journal of Consumer Culture* 5.2 (2005): 235–58.
16 Scholz, 'Why Does Digital Labour Matter Now?': 10.
17 Alvin Toffler, *The Third Wave* (Bantam Books, 1980).
18 George Ritzer and Nathan Jurgenson, 'Production, Consumption, Prosumption: The Nature of Capitalism in the Age of the Digital "Prosumer"', *Journal of Consumer Culture* 10.1 (2010): 13–36.
19 Detlev Zwicj, Samuel K. Bonsu and Aron Darmody, '"Co-creation" and New Marketing Governmentality', *Journal of Consumer Culture* 8.2 (2008): 166.
20 Tiziana Terranova, *Network Culture: Politics for the Information Age* (London: Pluto Press, 2004): 73.
21 Steven Flowers et al., *The New Inventors: User-led Innovation in Four Sectors* (London: NESTA, 2008): 4.
22 Mark Andrejevic, 'Exploiting YouTube', in *The YouTube Reader*, ed. Patrick Vonderau and Pelle Snickars (Stockholm: National Library of Sweden, 2009): 33–51.
23 Lise Lareau, 'The Impact of Digital Technology on Media Workers: Life Has Completely Changed', *Ephemera* 10.3/4 (2010): 524.
24 Rosalind Gill and Andy Pratt, 'In the Social Factory?', *Theory, Culture & Society* 25.7–8 (2008): 1–30.
25 Ross, 'In Search of the Lost Paycheck': 16.

Trekker, Google Street View Backpack Camera. Courtesy of Eli Duke

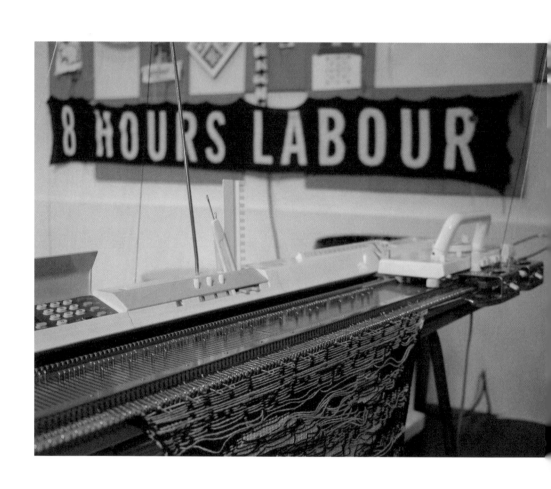

Punchcard Economy
Sam Meech

Reinterpreting the heritage of the textile industry in the north west of England, while documenting the current experience of the freelance creative, *Punchcard Economy* comprises a machine-knitted banner based on the '8 hours labour, 8 hours recreation, 8 hours rest' slogan coined by Robert Owen of the Eight-hour Day movement. The design incorporates data collected from a range of 'workers' in the digital, creative and cultural industries, auditing contemporary working patterns within the digital economy, and revealing the shift from Owens's '8−8−8' ideal. The final work is produced on a domestic knitting machine using a combination of digital imaging tools and traditional punchcard systems.

The punchcard has played a role both in the development of textiles technologies (through, for example, the Jaquard loom and the domestic knitting machine) and in early digital computing systems. Punchcards have also traditionally been used as a mechanism for logging working hours and thus controlling the time of workers.

The popular introduction of domestic knitting machines in the 1950s brought the factory into the home, and saw the elevation of a hobby into a one-person cottage industry. Though Brother ceased production in the 1990s, hobbyists and professionals have kept the craft alive through sharing techniques via video tutorials and blogs. More recently the electronic knitting machine has become popular with hackers and makers.

As digital tools allow us to engage in work at home (or in transit), the distinction between work, rest and recreation is increasingly lost. Whether a freelancer or a full-time employee, we often struggle to avoid 'bringing your work home'.

Punchcard Economy is a development of the artist's work with the NEPHRA Knit and Natter group in New Moston, exploring the overlap between knitting machines and digital imaging, and his research into textiles manufacturing history in North Manchester.

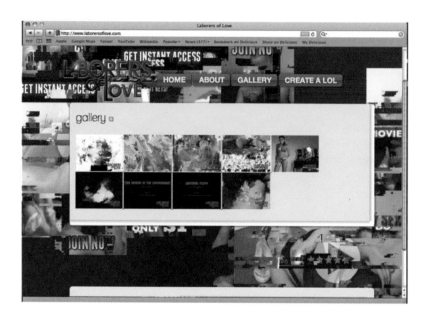

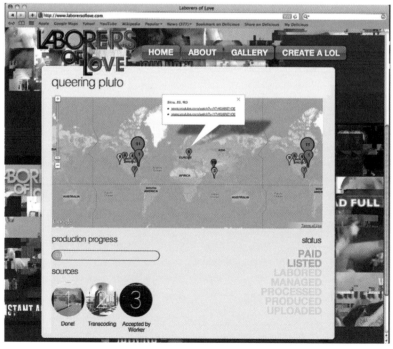

Laborers of Love/LOL
Stephanie Rothenberg
and Jeff Crouse

Outsourcing just got hotter with Laborers of Love/LOL!
Laborers of Love (LOL) is your perpetual fantasy machine. Create your
ultimate, customised fantasy in real time all the time with our endless supply of quality
online laborers working just for you. We never sleep and neither will you once you
try our fantasy engine.

Laborers of Love/LOL is a crowdsourcing project that explores how sexuality and
desire are mediated through new technologies, specifically new models of global,
outsourced labour. The project evolved from Crouse and Rothenberg's earlier
project *Invisible Threads*, a virtual sweatshop in Second Life. *LOL* takes the form
of an adult entertainment website that uses anonymous online workers to create
'customers' video fantasies. Utilizing Mechanical Turk, an online job engine created
by Amazon.com (www.mturk.com), *LOL* leverages a global online workforce of
workers that are not specific to the sex industry but rather a diverse group of home/
computer-based workers. In an assembly-line fashion, Mechanical Turk workers
collect images and video related to the fantasy from a variety of websites. A real-
time data visualisation is then presented on the website consisting of worker loca-
tions (Waco, Texas, Bangalore, India etc.) and IP addresses of the mined content
(images and video). This visualisation maps the process and 'production' of the
video fantasy. The final product is a short video mashup where 1970s experimen-
tal cinema meets canned Photoshop filters, and ultimately reflects on how desire
and pleasure are represented, fragmented and abstracted through the consump-
tion of online digital media.
www.laborersoflove.com

Minimum Wage Machine
Blake Fall-Conroy

The Minimum Wage Machine allows anybody to work for minimum wage. Turning the crank will yield one penny every 4.97 seconds, for $7.25 an hour, United States' statutory minimum wage (before taxes). If the participant stops turning the crank, they stop receiving money. The machine's mechanism and electronics are powered by the hand crank, and pennies are stored in a plexiglas box. The machine can be reprogrammed for different locations and currencies.

This project attempts to distill the act of working down to its most fundamental ingredients: turns of a handle, seconds of a clock, and pennies of currency. At this basic level, the act of working the machine to earn money becomes visceral. While not explicitly taking a side, the project strives to spark discussion on the value of wage labour, the nature of minimum wage, and capitalism as a whole.

Minimum Wage Machine was re-created for the Time & Motion exhibition as part of the engagement programme at FACT. Members of Freehand, FACT's young people's programme, worked in collaboration with both the artist and local design engineer Patrick Fenner to refabricate the machine and discuss the timely themes behind the work.

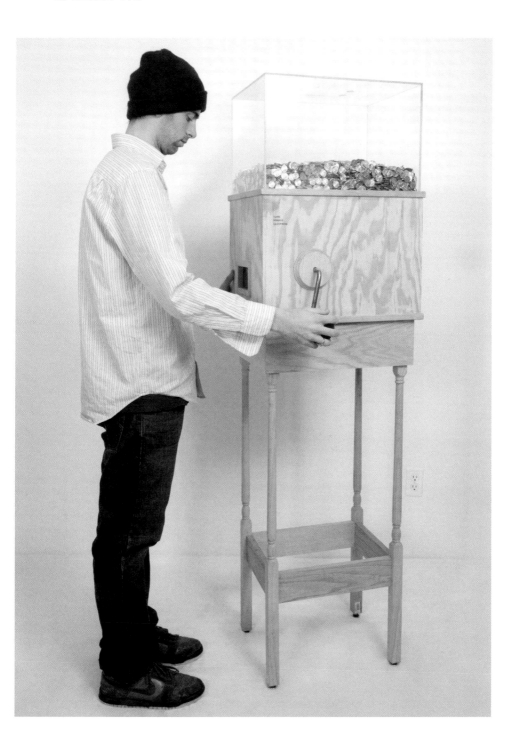

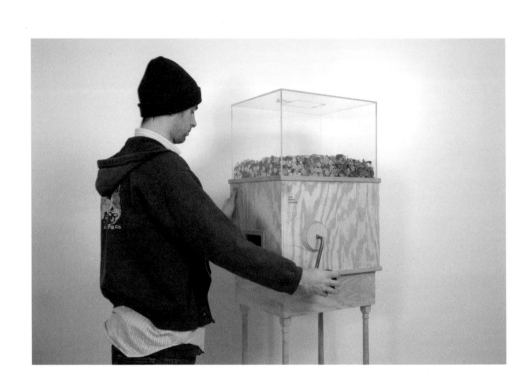

HOW DO

YOUR

TIME

YOU VALUE

SPENT?

The Value of Time Spent
Mike Stubbs

Thank you for taking the time to read these words. I hope you value not only my physical effort in typing on these computer keys (less expended than on a mechanical typewriter or than with a pen), but also the knowledge and thinking power I am bringing to the page. I am assuming you are not reading this professionally and therefore not being paid to read, though having more knowledge and something to talk about will possibly improve your employability. On average, writers are paid one pence per word. On this occasion I am writing as part of my salaried job, but I am very interested in this subject and it is a real pleasure. I am enjoying the process and feel a sense of autonomy and control. If I was writing copy for an advert for false tans, I might feel differently.

Work to rule, the 'go-slow' or time-wasting have traditionally formed types of protest within historical settings of industrial dispute and precede the strike. Being seen to move slowly or to make no physical movement at all is a clear signal of non-activity or disruptive behaviour. It's the stage before strike action begins, whether swinging pickaxe or tapping keystroke. Slow movement and duration also form components of performance art or Actionism. Dadaism actively confounded oppressive systems of war and logic. Artists such as Tristan Tzara and Kurt Schwitters were major proponents of these movements and created art which challenged rationality and order. Artists have continued to deconstruct or re-appropriate not only through ideological motivations, but also through an ontological approach to the world, reflecting on our assumptions as to how it functions; the curiosity to look at things more closely and observe subtle differences and values.

Artists are neither loafing nor lazing; they are driven, motivated and virtuous – and they create new value for themselves, to share with others. However, this contradiction and tension between risk-taking and the desire to reconsider value can profoundly challenge our naturalised paradigms of efficiency.

Our current pervasive socially networked condition is a happy bundle of work-life balance, 24:7; we are the machine

In the 1970s, performance artists Chris Burden and Tehching Hsieh committed dangerous acts: *Shoot* (1971), where Burden is shot in the arm by a friend, and Hsieh, who jumped from a window to perform *Jump Piece* (1973) breaking both of his ankles. Hsieh to this day prefers not to discuss this work. However, these actions represent the antithesis of efficiency, having more in common with self-mutilation associated with deserters during active service and workers trying to get off the production line through self-inflicted injury, extreme forms of the 'go-slow'.

However, for *Time & Motion*, it is Hsieh's *One Year Performance*, which is most suitable as an icon of challenging our notions of time, labour and value in the context of Taylorist efficiency. When I introduced Teching Hsieh in Sheffield in the early 1990s, the artist replied, 'thanks Mike, for wasting my time', a provocation potentially insulting the host and audience, but really provoking a question as to the value of time spent at its most fundamental level.

In *One Year Performance* (*Time Clock Piece*) (1980–81), Hsieh 'clocks on' every hour for a year, day and night, in the self-made cell of his studio. Hsieh rejects our assumptions on how we spend our time, begging fundamental questions on how we create value and how we value time spent. Not only that, he fundamentally challenges any notion of 'productivity' as might have been determined through a efficiency study as prescribed by Taylorism or the invention of mass production in Henry Ford's car plant of the early 1920s. Charlie Chaplin still reminds us, in the classic film *Modern Times* (1936), how we are always trying to keep up with the machine, quite literally being crushed by a cog. Then, in a new modernist world, fear of industrialisation seemed real and clear, anxieties of time, space and productivity made manifest.

Artists have explored most aspects of the contemporary world, suggesting new modalities of life and existence. New types of relationships and scenarios, formed through digital networks, artificial intelligence and big data, present incredible opportunities and challenges. In adjusting to a society where productivity continues to increase while employment opportunities decline, we

are becoming progressively detached from the physical mechanical world our forefathers helped shape.

Our current pervasive socially networked condition is a happy bundle of work–life balance, 24:7; we are the machine. Systems of value creation, labour and self are further entwined. As we wrestle with new realities of a globalised experience economy, work and recreation have become increasingly blurred. We are confronted with learning new definitions of consumption and production, with our multiple digital identities across shrinking distances in compressed time. The abstraction of our digital domain is constantly diminished as our ability and desire to see finer detail and algorithmically track *everything* advances. As our devices to perceive this detail improve, so we can better define the way digital becomes tangible.

Data always has been material and we learned from Nicholas Negroponte's *Being Digital* in 1995 [1] that the cables along which this data travelled were the new motorways. We have no excuse to consider digital as an abstraction, nor drone attacks nor cyber bullying. Operators *do* know when they kill the enemy flying unmanned drones into battlefields.

Redefining working life in digital space is one of many areas of research that needs attention. Those that still see the ocean as a bottomless pit and digital space as an infinite 'other' need help in visualising alternatives; we are the 'other' and we have compelling environments to help people learn. Design for disassembly, for example, is another way to look at built-in obsolescence. With combined technologies and learning, we can rethink manufacture and disposal, considering the end of the life of stuff, conversion of waste to fuel, whether digital noise, redundant data, bio-mass or the clinker from smelting iron, what Ned Rossiter terms 'dirt research'. [2]

More than 27 million people play *MineCraft*, a game where, starting with a landscape and a pickaxe, players can produce their own virtual world. It's a mass phenomenon that has captured imaginations and instincts, an environment of online collaboration, industry and destruction. Dubbed 'first-person Lego', this is a sociable space of design, asset management, life and death, a game with few rules placing the player at the centre of a domain to be built. Games like this are the manifestation of media theory and experiments practised by scientists and media artists in the past, now providing user-friendly bricks in redefining our understanding of identity and embodiment. With novel values of exchange proliferating across all aspects of life, trading digital assets is imbued with as much belief as collecting art or panning for gold. For a 10-year-old, putting the pick down

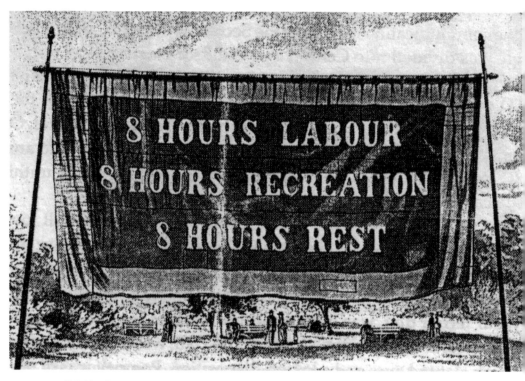

Eight Hour Day Banner, Melbourne, 1856

is hard, even when it's bedtime, the sense of purpose, pleasure in making and peer pressure to collaborate is immense, even if the giant model of the titanic has 'no purpose'.

75 *Watt* (2013) is an artwork in the *Time & Motion* exhibition that reverse engineers value in the supply chain. Artists Cohen Van Balen collaborated with choreographer Alexander Whitley and a group of workers in a Chinese factory, hired specially to make a 'useless' physical object. However, the product of the labour on the production line is a dance, not useful and not an object as we have come to know it. In a society where all leisure and work are interchangeable, a series of movements by the workers can be perceived as the product, which embodies a complex set of relations on a global stage while actioning a new form of trusting relationships. These relationships fundamentally challenge assumptions of industrialised labour and consumption. Producing 'nothing' is a highly relevant and valuable proposition for a 'bling' society still obsessed with gold-plated Bentleys and champagne lifestyles.

Seventy-five watts is the average output of energy a human can expend in a day. What if we speculate on how that energy can be employed to create many outcomes and products, such as a dance? We have choice in all we do, yet when labour is channelled and when those 75 watts are multiplied by a workforce of 2,000 men and women in an Amazon distribution warehouse, do those 150,000 watts of energy get used to further our humanity and give people meaning in life, or have we merely converted humans into robots?

The Coming Insurrection, a French political manifesto, describes contemporary working life thus:

> Today work is tied less to the economic necessity of producing goods than to the political necessity of producing producers and consumers, and of preserving by any means necessary the order of work. Producing oneself is becoming the dominant occupation of a society where production no longer has an object: like a carpenter who's been evicted from his shop and in desperation sets about hammering and sawing himself.[3]

Striving to achieve a work–life balance and now enabled to work anywhere, anytime, how are we going to differentiate along these traditional divisions? Nineties fantasies of working from the beach may have materialised for the super-rich. Work ethic, guilt, fear and pleasure drive those lucky enough to have

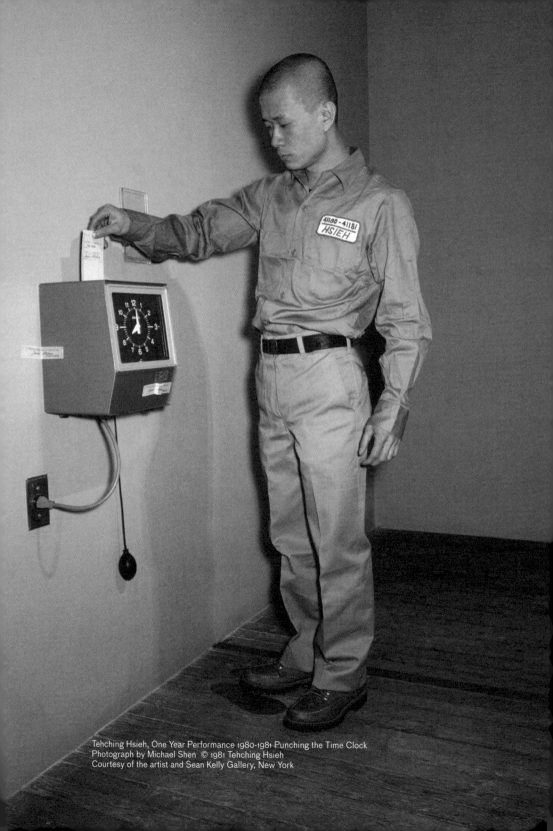

Tehching Hsieh, One Year Performance 1980-1981 Punching the Time Clock
Photograph by Michael Shen © 1981 Tehching Hsieh
Courtesy of the artist and Sean Kelly Gallery, New York

employment to overwork as always. The rubric of eight hours' work, eight hours' leisure and eight hours' rest – fought hard for in the nineteenth century during the campaign for the eight-hour day – evaporates for most us as our leisure is the work and our work the leisure. Do you have one or two Facebook accounts? How are those under-employed contributing within new economies across the world, as consumers and players, or is this just a way of dressing up mass unemployment and shifting the problem as employment patterns change?

As our future world of work involves hybrids of network, database and communication skills, traditional roles in clerical and office work become further vulnerable. As manufacturing represents only one in ten jobs in the USA and is increasingly automated with industrial robots, this starts to show a trend that productivity continues to grow while employment diminishes. What dirty labour there is left to do can be migrated to the latest place where people work for the lowest wage, where robots are too expensive or have not had those competencies designed in as yet. However, this is a transitionary phase – as healthcare and education become distributed via new technology, and mining gets automated, we really could be heading for a worldwide state of unemployment.

My grandfather owned his first watch on retirement, when he needed it least. Until then, he had relied on the Vickers shipyard hooter to signal the end of the working day, as did his wife, to put on his tea. The hooter was the town's clock. Workers leaving the factory are more difficult to discern when they are remote workers logging out of their computers, but although the factory gates may be digital they are just as real for most. In the Lumière film of 1895, *Workers Leaving the Factory Gates*, there is clearly a factory and a place of work. The utility of spent is less easy to evidence when work has become tacit in a knowledge economy, or through transactional work such as in the service industries, than in what *Time & Motion* collaborator Jeremy Myerson terms 'transformational work',[4] where objects are hewn of stuff and raw materials such as steel are converted into cars.

Value creation relies on the suspension of disbelief, meaning that the act of persuasion and transaction has always had as much to do with commanding a good salary over earning a wage through brute strength and stamina, often based on historic distortions of power and privilege. The knowledge economy is testament to that. Within the context of looking in an art gallery, audience affect and learning are as important to our economy of operation and function as the production of art. We count visitors in a free exhibition to prove the social worth of the art experience, or sell tickets and the market dictates its need. To reveal the tacit understanding

within the transactions and understand better where lies the intrinsic quality in a contemporary centre where we have already pioneered consumers becoming producers with digital technology, we both use algorithms and personal contact with more effect.

Understanding digital preferences and 'liking' driven by powerful algorithms, real-time feedback loops can improve products, services and our overall experience. The symbiosis between tourist guide and tourist, seller and shopper, artist and audience are constantly monitored to improve business. Taken across most aspects of society, all our relationships and experiences might become more refined, efficient and pleasurable, leading to an improved quality of life for all. But how is automation, with its new rhythm of time and space, helping to spread the load when, for many, work still looks like it did for their grandparents: physical graft? Mechanised docks in Liverpool provide a fraction of the opportunities they did in the 1960s. How will we spend our time going forward when we are still wedded to expectations, models of labour and societal contracts located in the wrong industrial revolution?

The mine in Carmaux, famous for violent strikes, has now been reconverted into an entertainment multiplex

Within this context, the *Time & Motion* programme at FACT is an experiment in collaborating with a range of creative producers and researchers across the venue, audiences, work and digital spaces. It is a creative enquiry into new types of working life, asking the public to contribute their views and also contribute to a real-time experience, provoking and challenging us to question how we spend our time and whether we are working, playing or sleeping. As we move from utopian fantasies of labour-saving devices to a reality of 'endless work', mass surveillance and cyber-loafing, how are we coming to terms with these new patterns and social impacts? We are living the paradox of a society of workers without work, where entertainment, consumption and leisure only underscore the lack from which they are supposed to distract us. The mine in Carmaux, famous for a century of violent strikes, has now been reconverted into Cap'Découverte, an entertainment multiplex for skateboarding and biking, distinguished by a Mining Museum in which methane

blasts are simulated for vacationers.[5]

This is not only a polemic on work and labour and a questioning of fairness, but also a proposition on how we can extract value and meaning through observing the incidental and incremental, how we can accept that quality can be found in most things and genuinely innovate better ways of extending across space and time. Was the American worker who outsourced his own job to a Chinese worker cheating his boss or synthesising smarter ways of working?[6] Digital or otherwise, equality of time and labour needs to be fair and time spent needs to be as pleasurable as we can make it, reminding ourselves to keep moving, enjoy the rhythms and enjoy work as another part of life.

I write these notes from my bed, the kids are playing *MineCraft*, I am privileged in not having to brave the cold and rain on a black bike to get to the factory gates. It is 6.30 a.m. and I am just starting my 12-hour day on a laptop. ∎

1 N. Negraponte, Being Digital (New York: Alfred A Knopf, 1995).
2 N. Rossiter, 'Dirt Research', in Depletion Design: A Glossary of Network Ecologies, ed. C. Wiedemann and S. Zehle (Amsterdam: XMLab and the Institute for Network Cultures, 2012): 41–45.
3 The Invisible Committee, L'insurrection Qui Vient (The Coming Insurrection) (Los Angeles: Semiotext(e), 2008): 32.
4 J. Myerson, J. Bichard and A. Erlich, New Demographics, New Workspace: Office Design for the Changing Workforce (Farnham: Gower, 2010).

5 www.smad-capdecouverte.com/accueil.html.
6 C. Davies, 'Software developer Bob outsources own job and whiles away shifts on cat videos', The Guardian 16 January 2013, www.theguardian.com/world/2013/jan/16/software-developer-outsources-own-job.

One Pound
Oliver Walker

One Pound is a six-channel video installation, with each channel depicting one person working. Each video lasts as long as it takes the person depicted to earn one pound.

The films vary in length from several hours for some of the lowest paid workers in the world to their counterparts in urban areas, via those on lower- and middle-income Western wages, down to several seconds for well-paid workers in finance, and with one film little over a second long.

The films do not offer a narrative, but rather quite detached observations of people at work. It is not intended as a didactic essay on wage inequality. Clearly, it may offer reflection on these staggering inequalities, and this political position is ultimately not left ambiguous. However, the relationship between labour and money is transformed into a more subjective medium – time. Periods of time are not as easily compared with one another as pieces of graphical information, for instance. With video, the timescale is embedded into the medium (unlike photography, or even text). Ultimately the people on the screens are simply taking part in their everyday lives, and we see six bodies on six screens, side by side.

EAT

Banana Multiplier

Job Title: Banana Multiplier
Location: UK-NW-Liverpool
Industries: Trading
Job type: Flexitime
Education Level: Non
Salary: Earned bananas

2 green bananas = 1 ripe banana
If you buy bananas in a supermarket, they are always too green to eat immediately.
So why don't you trade your green bananas with more nutritious ripe ones?
Just go to Banana Multipliers standing by the entrance of a supermarket and exchange two of your green bananas with one fully ripened banana.
The wage for a Banana Multiplier is earned bananas.

Noodle Advertiser

Job Title: Noodle Advertiser
Location: UK-NW-Liverpool
Industries: Advertising
Job type: Flexitime
Education Level: Non
Salary: A bowl of noodle

Eating noodles at night near china town spotlighted by a rucksack type carrying device to advertise 'noodle' itself.

SHELTER

Doppelgänger-self

Job Title: Doppelgänger-self
Location: UK-NW-Liverpool
Industries: Agent
Job type: Flexitime
Education Level: Non
Salary: Varies

When people running their businesses on their own want to have holiday, they need to close their shops/services for that period.
So why don't you replace those people temporarily?
At least you have a place to stay during the day time and you might be able to get some reward from the owner! All you need is trust...

Holiday Residential Security Guard

Job Title: Holiday Residential Security Guard
Location: UK-NW-Liverpool
Industries: Security
Job type: Flexitime
Education Level: Non
Salary: Varies

When people are on holiday, they are always worried about burglars breaking into their houses. So why don't you stay at those people's houses while they are away? Before people go on holiday they try to clean the fridge as food is going bad but just ask them to leave it for you to eat! If you can fluently move from one house to another throughout the year, then you don't need your own house!

SECURE RESOURCES

Internet Binder

Job Title: Internet Binder
Location: UK-NW-Liverpool
Industries: door-to-door sales
Job type: Flexitime
Education Level: Non
Salary: Extra fossil fuels to generate electricity will be saved

Visiting people's houses to ask whether they want to share their internet connections with neighbors.
If you trust your neighbors then there is no reason why you have your own connection and pay extra money.

Public Advertiser

Job Title: Public Advertiser
Location: UK-NW-Liverpool
Industries: Advertisement
Job type: Flexitime
Education Level: Non
Salary: Unused public resources will be utilized

Making advertisement for public properties - a particular tree, staircase, gate or whatever you like and want to promote.
Design flyers, print them, and distribute among the public.

AMAZING TREE — this tree is just nice to look at and climb!

BE CONNECTED

"Text to Net" service provider

Job Title: "Text to Net" service provider
Location: UK-NW-Liverpool
Industries: Assistance
Job type: Flexitime
Education Level: Non
Salary: Being able to know people's activities

It's a system for people who have mobile phones but don't have internet access for security reasons or just because they cannot afford. Basically you can text to the registered mobile phone number to ask a simple question for which you can easily find the answer online if you have the internet. After asking a question you usually get the answer within 5 min. Making an email list, sending all the questions through the members, people search on the web and the first answer will automatically be sent to the asker.

Text to Net!

Alternative Income Stream Creator

Job Title: Alternative Income Stream Creator
Location: UK-NW-Liverpool
Industries: Finance
Job type: Flexitime
Education Level: Non
Salary: You might also get 1p sometimes

Making a small new money exchange stream by placing 1p with a piece of paper saying, "Feel free to take one"
This can be placed anywhere, in a fast food chain, park bench, library, wherever.

Feel Free to Take One

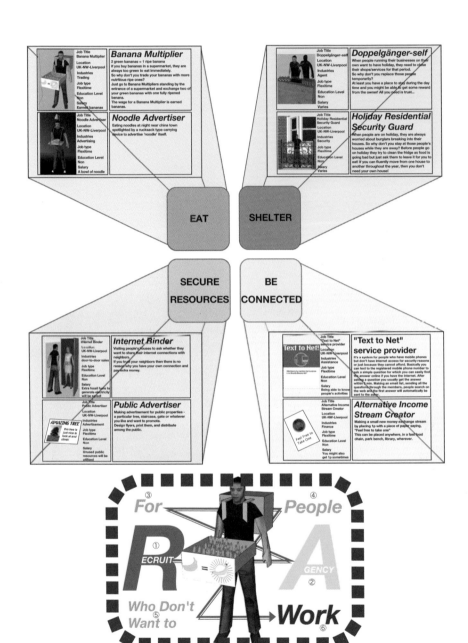

For People Who Don't Want to Work

① RECRUIT ② AGENCY

Recruit Agency for People Who Don't Want to Work
Inari Wishiki

Is earning money the easiest way to survive in this world? Is it true that you have to live to work and work to earn money? Why does everything seem so expensive, such as food, rent and travel? Can you not access those infrastructures without the process of earning money?

In the last ten years, there has been remarkable progress made in software and digital technologies. This has contributed to the rapid domination of automation which has made humans increasingly unnecessary in almost every aspect of life. For example, a few good flight search engines have expelled a million travel agents. However, the new use of human beings has not been established yet and so people are still expected to be useful for society in the manner of the industrial era. This ritual also remains in corporations: they have to pretend to be offering useful goods and services for society, whereas the only thing they need is money. Yes, all we need is money and with it, we can finally survive...

Recruit Agency for People Who Don't Want to Work is an attempt to let people engage in commerce while abandoning all the meaningless rituals of having to be useful to earn money.

Don't want to work just for money? Fed up with earning pennies per second? Well then, take up our opportunities to instantly make a living!

Through the jobs listed on our exclusive website, you can EAT, SHELTER, SECURE RESOURCES and BE CONNECTED without the hassle of bustling around for cash!

irational.org/inari/recruit

75 Watt
Revital Cohen and Tuur Van Balen

A product is designed especially to be made in China. The object's only function is to choreograph a dance performed by the labourers manufacturing it.

The work seeks to explore the nature of mass-manufacturing products on various scales; from the geo-political context of hyper-fragmented labour to the bio-political condition of the human body on the assembly line. Engineering logic has reduced the factory labourer to a man-machine, through scientific management of every single movement. By shifting the purpose of the labourer's actions from the efficient production of objects to the performance of choreographed acts, mechanical movement is reinterpreted into dance. What is the value of this artefact that only exists to support the performance of its own creation? And as the product dictates the movement, does it become the subject, rendering the worker the object?

The assembly/dance took place in Zhongshan, China between 10 and 19 March 2013.

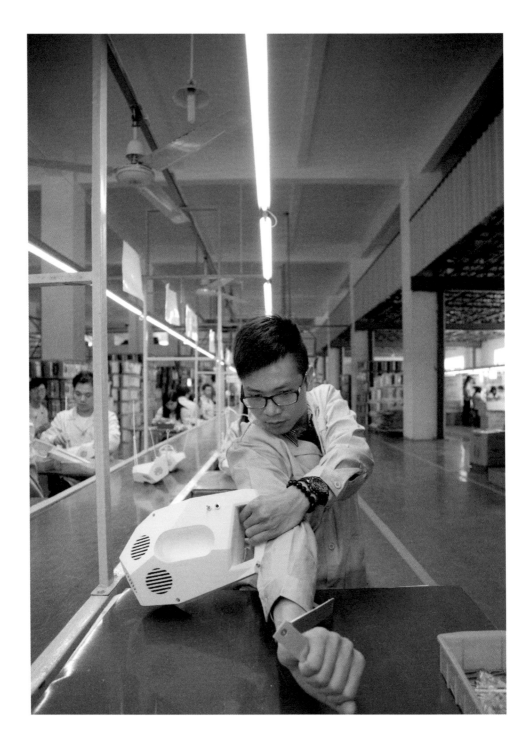

WHEN DOES

DOES

AND

LEISURE

WORK

FINISH

BEGIN?

Videogames and the Spirit of Capitalism
Paolo Pedercini

As she jumps over moving platforms, blows up barrels at the right time, collects glowing gems, looks for treasure chests, scores a head-shot, storms an alien base, perfects her racing line, upgrades her weapons, allots a perfect square of land, gets an extra life, recruits a companion, seizes mineable resources, invests in a new infrastructure, persuades a character, puts a falling block into place...as she learns by trial and error, wins, loses...as she does all of this, my fellow player may realise that all of her actions pertain to a specific mode of thinking and acting.

If computer games, in their immense variety, have anything in common, that may be their compulsion for efficiency and control. Computer games are the aesthetic form of rationalisation. In sociology, rationalisation refers to a process of replacement of traditions, customs and emotions as motivators of human conduct in favour of quantification and calculation. This notion was introduced at the turn of the twentieth century by Max Weber, in his influential book *The Protestant Ethic and the Spirit of Capitalism*.[1]

Computer games are the aesthetic form of rationalisation

Rationalisation, a long-term historical process, has its most obvious manifestations in the rise of bureaucracies and in the industrial organisation of production, which transformed our world in the last two centuries and continues today, engulfing increasingly larger aspects of our social life. While scientifically managed factories have nearly disappeared from our (Western) sight and rigid nation-state bureaucracies appear to be threatened by the fluid logic of networks, rationalisation is still at work in the sphere of culture and relationships.

Commerce, food production and consumption are stripped out of their cultural specificity for the benefit of the economy of scale (Walmartisation,

monoculture, McDonaldisation); education is being reformatted around quantitative assessment and mechanical reproducibility (standardised tests, massive online courses); even our daily relationships are efficiently managed through online social networks which impose standard protocols and numeric rankings on previously irreducible social interactions.

Videogames are built upon technologies of control and quantification, and they are still by and large informed by them. When we produce artful depictions of our world using computers, we inevitably carry over a cybernetic bias that could reinforce certain assumptions and mindsets. From the eyes of a computing machine, everything is mathematically defined and susceptible to rational calculation.

Since games are typically goal-oriented, all the elements and relationships within them tend to be reduced to means and ends. Developers frown upon introducing non-functional core mechanics as they represent an unnecessary cost and may add levels of ambiguity, which alienate players. The verbs characterising players' action, when not related to direct violence, belong to the arsenal of rationalisation: solving, clearing, managing, upgrading, collecting, estimating and so on.

In strategy and management games, the simulated world is presented as a collection of resources to extract. The landscape is often subdivided into spatial units by grids or cells, and the actors inhabiting it are defined by the function they perform. Historical games like *Civilization* (1991) even project this modern vision towards the past, portraying ancient societies functioning like imperialistic nation-states devoid of any tradition or system of values other than the drive toward expansion.

Skill-based videogames, such as single-player arcade, platformers or first-person shooters, rarely leave room for creative or expressive play and demand efficiency of movements within clockwork environments. The phenomenon of 'speedruns' (the recording of sessions performed as fast and flawlessly as possible) is the extreme response to this demand: the enthusiastic fruition of game spaces according to Taylorist principles. A great number of puzzles, from *Tetris* (1984) onward, deal with the systemic theme of order versus disorder and can be seen as abstract exercises in rationalisation. The iPhone game *Async Corp.* (2011) goes as far as to include this theme in its narrative presentation, complete with ironic use of corporate management lingo.

Interpersonal relationships appear regularly instrumentalised in videogames. The Other, other from the player, exists only *as a function of* the player. Non-playing characters are typically locked into friends v. enemies binary roles. Animal companionship in *Pokemon* (1996) is warped into a twisted proxy fight,

while romance in action/adventure games appears as a mere plot device, usually involving an objectified female character.

Contemporary trends in game development offer even more clear examples of this special relationship between computer games and instrumental rationality.

In videogames as in society at large, we can find subterranean tendencies and fleeting acts of resistance that tenaciously reaffirm the irreducibility of human consciousness

Social games on Facebook and mobile devices have been the fastest-growing sector of the gaming industry in recent years. With hits like *Farmville* (2009), San Francisco-based company Zynga achieved an almost complete dominance of the market, acquiring hundreds of millions of active users in the span of a few months. This explosive success is in large part due to the player-driven viral promotion of these titles. The 'social' aspect of social games consists in the exploitation of pre-existing friendship networks: information about game-events is automatically posted on social media and players are constantly encouraged to convert Facebook contacts into new users. The motivation to recruit new players, however, is not the pleasure of a game in the company of friends (direct interaction between users is paradoxically very limited in this type of game), but rather to benefit from their occasional help. In other words, players are encouraged to see their non-playing friends as potential resources to further their individual goals.

Farmville and its spin-offs are peculiar in that they are both the products and the heralds of a rationalising ideology. Their themes deal with the management and expansion of farms, cities, restaurants or castles, and their gameplay demands a constant negotiation between in-game and off-game time. Every action costs a substantial amount of idle time (symbolising labour), which forces the player to put the game session in stand-by for minutes or hours before advancing another step. The optimisation of game time bleeds into the players' lives, as they may interrupt other activities to take care of their virtual cows. To the most impatient players, Zynga offers a way out of this dreary routine: players can pay 'real' money

to acquire upgrades and virtual goods instantly, bypassing long waits. Needless to say, these paid shortcuts have been the main source of revenue for Zynga.

Why do people decide to subject themselves to exploitative systems like *Farmville*? The reasons are several: they cater to non-habitual players with simplistic, stress-free mechanics; they provide a space for self-expression and identity performance online; they tap into a common consumerist compulsion offering a cheaper alternative to the hoarding of physical commodities.

But, above everything, these games are the result of a rigorous design process that maximises addictiveness.

Traditional game design, despite the industrial organisation of major game companies, has always been considered a creative and, to some extent, intuitive process. What Zynga perfected is an iterative, scientific approach to game-making where every user interaction is registered and analysed. The most effective elements (i.e. whatever pushes players to spend more money or return more frequently) are then amplified and multiplied throughout the game. In this metrics-driven process, users become assets from whom to extract value, as opposed to audience or loyal fans paying for entertainment.

To bring everything full circle, enter the concept of gamification. The marketing buzzword refers to the application of game-like elements such as points, quests and levels to non-game activities in an effort to make them more fun and engaging. Gamification techniques attribute arbitrary and quantifiable rewards in an attempt to incentivise certain actions such as generating content online, adopting a specific pattern of consumption or acquiring 'positive' habits. The users' score is typically made public to leverage a desire for competition and status.

The hype surrounding gamification raised many objections regarding the effectiveness of such a crude form of behavioural control, but these concerns should be left to marketers' speculation. Feasible or not, gamification is the object of desire of contemporary capitalism and, as such, deserves attention because it prefigures trends to come. It's the fantasy of measurement of the immeasurable (lifestyle, affects, activism, reputation, self-esteem and so on), as measurement is a precondition for commodification. It's the new frontier in the rationalisation of our lives.

French sociologist Roger Caillois famously noted that play is 'an occasion of pure waste: waste of time, energy, ingenuity, skill, and often of money'.[2] Playing games per se may appear as the ultimate non-instrumental activity, the perfect antithesis to economic production and reproduction. But the act of playing,

especially of the computer-assisted, cybernetically biased variety, can cultivate
the capitalist mindset and value system, regardless of what the specific games are
intended to portray or narrate.

It is certainly not hard to find instances of rationalisation and instrumental
thinking in the world we inhabit. What Max Weber painted as an 'iron cage' may
have simply become the air we breathe in capitalist societies. Yet, in videogames
as in society at large, we can find subterranean tendencies and fleeting acts of
resistance that tenaciously reaffirm the irreducibility of human consciousness.
Outside the mainstream, more and more independent works are rejecting rigid,
goal-oriented gameplays in favour of exploration and non-linear storytelling.

The so-called 'notgames' crafted by Belgian developers Tale of Tales
pose ambiguous challenges and intentionally deter a 'teleological' mode of play.
The sensual, dreamlike nature of their creations offers a rich alternative to the
world of ends and means of traditional games, without stripping the player of her
agency. The synesthetic exploration game *Proteus* (2013) revolves around the idle
enjoyment of a desert island as it changes though seasons. *Proteus*'s hyper-nature
is sacred by design: it can't be exploited nor manipulated, but only experienced
with the attentive eyes and ears of an ethologist, botanist and weatherman.

Storytelling can be a powerful balancing force in the calculated worlds of
computer games. Richard Hofmeier's *Cart Life* (2013) is a 'working poor simulation'
destined to become a landmark title in the growing movement of art house games.
Cart Life puts the player in the shoes of a single mom or a migrant worker trying to
make a living by operating a pushcart or a newsstand. The twist on the well-known
lemonade stand genre is in the painstaking simulation of the most disparate aspects
of everyday life. The player has to apply for permits, fight in court for the daughter's
custody, rest and eat regularly, take care of her cat and loved ones, possibly fall in
love, all of this and much more while trying to keep her business afloat.

The brilliance of *Cart Life* is in the way it puts narrative and exploration
elements in direct competition with the brutal resource management gameplay.
There is an economy of material necessity made of debt, logistics, paper napkins
inventory, swift espresso-making gestures, and a parallel 'human economy' of
relationship, reputation, love and care. As in *Proteus*, there are many little gems
disseminated in a sprawling scenario: unexpected dialogues and interactions,
backstories, whimsical sequences, but in order to experience them the player has
to subtract precious time from her quantifiable activity. In *Cart Life* the numeric,
formalised, computational core of the game is exposed in its harshness while the

loose, narrative, player-driven component outlines an enticing world of qualities – possibly, even a different way of living.

There are many ways to deal with the cybernetic bias of videogames. In my Molleindustria project I often deal with issues of alienation and labour. Games such as *Tamatipico* (2003), *Turboflex* (2003), *Every Day the Same Dream* (2009) or *Unmanned* (2012) thematise the struggle of individuals inscribed into bureaucratic and dehumanising systems. I also tried to create alternative management games that problematise the issue of rationalisation. Games like the *McDonald's Videogame* (2006) or *Oiligarchy* (2008) embrace tropes and conventions of the genre: players manage a production process trying to maximise profits, they are presented with an objectified nature ready to be exploited, they invest resources according to numerical trends and feedback.

But instead of portraying these activities as *natural* and *neutral*, these games introduce elements of criticality that subvert players' expectation: the exploitation of the environment has troubling consequences, the attempts to exert control over workers, consumers and indigenous populations cause backlashes and protests and so on. In a nutshell, the so-called 'negative externalities' of a production process and the capitalist conflicts are included in the simulated world, sometimes at the expenses of playability and elegance in design.

We are only learning to speak of immeasurable qualities through videogames. It's a slow and collective process of hacking accounting machines into expressive machines. Computer games need to learn from their non-digital counterparts to be loose interfaces between people. A new game aesthetic has to be explored: one that revels in problem-making over problem-solving, that celebrates paradoxes and ruptures, that doesn't eschew broken and dysfunctional systems because the broken and dysfunctional systems governing our lives need to be unpacked and not idealised.

Strategies are to be discovered: poetic wrenches have to be thrown in the works; gears and valves have to grow hair, start pulsing and breathing; algorithms must learn to tell stories and scream in pain. ▌

1 M. Weber, *The Protestant Ethic and the Spirit of Capitalism* (London: Unwin Hyman, 1905).
2 R. Caillois, *Man, Play, and Games* (London: Thames and Hudson, 1961): 5.

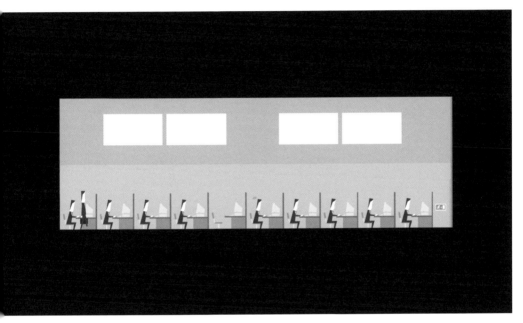

Image: Every Day the Same Dream, 2009. Courtesy of Molleindustria

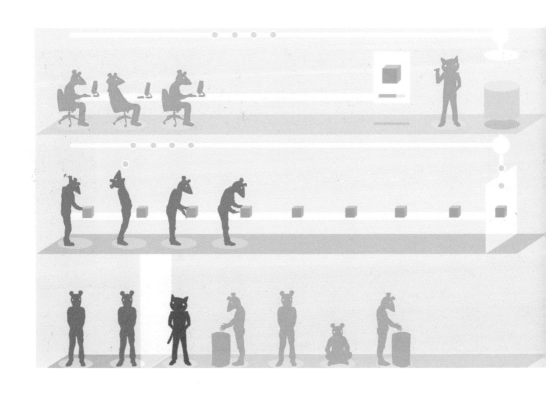

To Build a Better Mousetrap
Molleindustria

A semi-abstract management game that examines the tension between labour, meta-labour, automation, unemployment and repression.

iPaw
Electroboutique
(Aristarkh Chernyshev and Alexei Shulgin)

Pawing stroking touching shaking
Pawing stroking touching shaking
Pawing stroking touching shaking
Pawing stroking touching shaking
My new gadget is sooo cool!

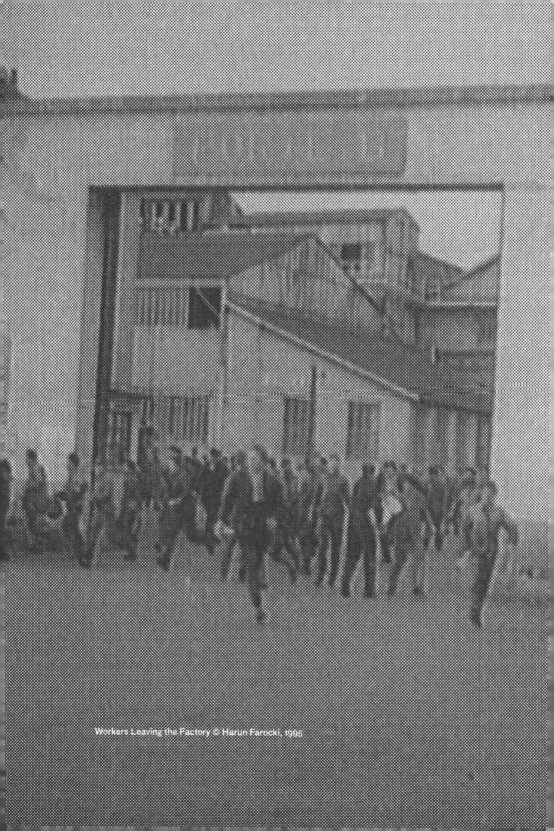

Workers Leaving the Factory © Harun Farocki, 1995

02 REPRESENTATION

WHAT

DOES

YOUR

LOOK

WORKING LIFE

LIKE?

Workers Leaving the Factory
Harun Farocki

The film *Workers Leaving the Lumière Factory in Lyon (La sortie des usines Lumière à Lyon*, 1895) by the brothers Louis and Auguste Lumière is 45 seconds long and shows the approximately 100 workers at a factory for photographic goods in Lyon-Montplaisir leaving through two gates and exiting the frame to both sides.

Over the past 12 months, I set myself the task of tracking down the theme of this film – workers leaving the workplace – in as many variants as possible. Examples were found in documentaries, industrial and propaganda films, newsreels and features. I left out TV archives which offer an immeasurable number of references for any given keyword as well as the archives of cinema and television advertising in which industrial work hardly ever occurs as a motif – commercial film's dread of factory work is second only to that of death.

Berlin, 1934: Siemens factory workers and employees leave the premises in marching order to attend a Nazi rally. There is a column of war invalids, and many are wearing white overalls as if to bring the idea of militarised science into view.

German Democratic Republic, 1963 (without precise localisation): a *Betriebskampfgruppe* – a works combat unit or militia made up of workers under the leadership of the party – turn out for manoeuvres. Very serious men and women in uniform get onto military light vehicles and drive to the woods where they will encounter men who themselves wear caps and pose as saboteurs. As the convoy drives out through the gate, the factory has the appearance of a barracks.

Federal Republic of Germany, 1975: a small loudspeaker van is parked in front of the Volkswagen plant in Emden and plays music with lyrics by Vladimir Mayakovsky and vocals by Ernst Busch. A man from the labour union calls on the workers leaving the early shift to attend a meeting protesting against the plan to transfer production to the USA. The labour union uses optimistic, revolutionary music as backing for the image of industrial workers in the Federal Republic of 1975; music echoing from the actual scene and not, as was the stupid practice in

so many films around 1968, just from the soundtrack. Ironically, the workers put up with this music precisely because the break with Communism was so total that they are no longer aware that the song evokes the October Revolution.

The first camera in the history of cinema was pointed at a factory, but a century later it can be said that film is hardly drawn to the factory and is even repelled by it

In 1895, the Lumières' camera was pointed at the factory gates. It is a precursor to today's many surveillance cameras which automatically and blindly produce an infinite number of pictures in order to safeguard ownership of property. With such cameras one might perhaps be able to identify the four men in Robert Siodmak's *The Killers* (1946) who, dressed as workers, enter a hat factory and rob the payroll. In this film one can see workers leaving the factory who are in fact gangsters. Today, cameras for the surveillance of walls, fences, warehouses, roofs or yards are sold already equipped with automatic video motion detectors. They disregard changes in light and contrast and are programmed to distinguish an unimportant movement from an actual threat. (An alarm is activated when a person climbs over a fence, but not if a bird flies past.)

A new archive system is thus on its way, a future library for moving images, in which one can search for and retrieve elements of pictures. Up to now the dynamic and compositional definitions of a sequence of images – those things which are the decisive factor in the editing process of converting a sequence of images into a film – have neither been classified nor included.

The first camera in the history of cinema was pointed at a factory, but a century later it can be said that film is hardly drawn to the factory and is even repelled by it. Films about work or workers have not become one of the main genres, and the space in front of the factory has remained on the sidelines. Most narrative films take place in that part of life where work has been left behind. Everything which makes the industrial form of production superior to others – the division of labour into minute stages, the constant repetition, a degree of organisation which demands few decisions of the individual and which leaves him or her little room for manoeuvre – all this makes it hard to demonstrate changes in circumstances.

Over the last century, virtually none of the communication that took place in factories, whether through words, glances or gestures, was recorded on film. Cameras and projectors are essentially mechanical inventions, and in 1895 the heyday of mechanical inventions had passed. The technical processes that were emerging at the time – chemistry and electricity – were almost inaccessible to visual understanding. The reality based on these methods was hardly ever characterised by visible movement. The cinecamera, however, has remained fixated on movement. Ten years ago, when large main-frames were still most commonly used, cameras always focused on the last remaining perceptible movement as a surrogate for their invisible operations – the magnetic tape jerking back and forth. This addiction to motion is increasingly running out of material, a phenomenon which could lead cinema into self-destruction.

Detroit, 1926: workers are descending the stairs of a walkway over a street running parallel to the main Ford Motor Company building. The camera then pans to the right with measured self-certainty, and a passage comes into view, large enough for several engines to pass through at the same time. Behind this there is a rectangular yard, large enough to land an airship. On the margins of the square, hundreds of workers are on their way to the exits and will only reach them after several minutes. In the furthest background a freight train pulls past in perfect coordination with the speed of the pan; a second walkway then jerks into the picture, similar to the first and whose four lanes of stairs are again crowded with descending workers.

The camera stages the building with such mastery and self-certainty that the building becomes a stage set, seemingly constructed by a subdivision of the film production company just to serve a well-timed pan-shot. The camera's authorial control transforms the workers into an army of extras. The main reason the workers are shown in the picture is to prove that the film is not of a model of an automobile factory, or put another way, that the model was implemented on a 1:1 scale.

In the Lumière film of 1895 it is possible to discover that the workers were assembled behind the gates and surged out at the camera operator's command. Before the film direction stepped in to condense the subject, it was the industrial order which synchronised the lives of the many individuals. They were released from this regulation at a particular point in time, contained in the process by the factory gates as in a frame. The Lumières' camera did not have a viewfinder, so they could not be certain of the view depicted; the gates provide a perception of framing which leaves no room for doubt.

The work structure synchronises the workers, the factory gates group them, and this process of compression produces the image of a workforce. As may be realised or brought to mind by the portrayal, the people passing through the gates evidently have something fundamental in common. Images are closely related to concepts, thus this film has become a rhetorical figure. One finds it used in documentaries, in industrial and propaganda films, often with music and/or words as backing, the image being given a textual meaning such as 'the exploited', 'the industrial proletariat', 'the workers of the fist' or 'the society of the masses'.

The appearance of community does not last long. Immediately after the workers hurry past the gate, they disperse to become individual persons, and it is this aspect of their existence which is taken up by most narrative films. If after leaving the factory the workers don't remain together for a rally, their image as workers disintegrates. Cinema could sustain it by having them dance along the street; a dance-like movement is used in Lang's *Metropolis* (1927) to convey an appearance as workers. In this film, the workers wear uniform work clothes and move in muffled, synchronous rhythm. This vision of the future has not proved correct, at least not in Europe or North America, where you can tell by looking at someone on the street whether they are coming from work, the gym or the welfare department. Capital is not – or to use the language of *Metropolis*, the factory owners are not – concerned with a uniform appearance of the work slaves.

It is because the image of community cannot be maintained once the workplace is left behind that the rhetorical figure of leaving the factory is often found at the beginning or the end of a film, like a slogan, where it is possible to leave it detached, like a prologue or epilogue. It is astonishing that even this first film already had something not easily surpassed. It makes a statement that defies immediate extension.

When it is a matter of strikes or strike-breaking, of factory sit-ins or lock-outs, the factory forecourt can become a productive setting. The factory gate forms the boundary between the protected production sphere and public space; there, just at the interface, is exactly the right spot to transform an economic struggle into a political one. The striking workers file though the gate, and the other castes and classes follow. That is not the way the October Revolution began, however, nor that in which the communist regimes were toppled. Nevertheless, one major contributing factor in the demise of Polish communism was that of a group of non-workers who held out in front of the gates of Gdansk's Lenin Shipyard during its occupation, in order to show the police that it was impossible

to clear the workers out of the factory secretly. Andrzej Wajda's *The Iron Man* (*Czlowiek z zelaza*, 1981) tells the story.

1916: D.W. Griffith presented a dramatic portrayal of a strike in the modern episode of *Intolerance*. At first the workers' pay is cut (because the associations want to morally improve, the workers demand more means), then as the strikers swarm onto the street, police with machine guns move in, take up position and mow the crowd down. The workers' struggle is shown here as a civil war. Their wives and children have gathered in front of their houses and are watching the bloodbath in horror. A group of unemployed eager to take the strikers' jobs is ready and waiting, literally a reserve army. This is probably the greatest shoot-out in front of factory gates in the hundred-year history of cinema.

If after leaving the factory the workers don't remain together for a rally, their image as workers disintegrates

1933: in Vsevolod Pudovkin's depiction of a strike by Hamburg longshoremen, *The Deserter* (*Desertir*), a picket has to watch ships being unloaded by strike-breakers. He sees one of the strike-breakers first swaying under the burden of a crate, then for a long time standing firm against the weight, and finally breaking down. The picket looks at the unconscious man lying there with cold social-historical attention, shadows darting across his face.

These shadows are cast by the unemployed men hurrying to the gates of the harbour area to take the collapsed worker's place. They are miserable, so sick from poverty that they have entered old age or second childhood. The picket looks deep into the face of an older man, whose tongue is playing with his saliva, and then turns away frightened. With so many people unable to find work or a place in a society based on work, how can social revolution be possible? The film shows the faces of the destitute through the bars of the entrance gate. They are looking out from the prison of unemployment to the freedom called 'paid labour'. Filmed through the bars they appear to have been shut away in a camp already. In the course of the twentieth century, millions of people were declared superfluous; they were deemed to be socially harmful or classified as racially inferior. They were locked up in camps by Nazis or Communists to be re-educated or destroyed.

Charles Chaplin accepted a job at the conveyor belt and was thrown out of the factory by the police during a strike... Marilyn Monroe sat at the conveyor belt of a fish cannery for Fritz Lang... Ingrid Bergman spent a day in a factory, and as she entered it, an expression of holy fright entered her face, as though on the road to hell. Movie stars are important people in a feudal kind of way, and they are drawn to the world of the workers; their fate is similar to that of kings who get lost while out hunting and thus come to know what hunger is. In Michelangelo Antonioni's *The Red Desert* (*Il Deserto Rosso*, 1964) Monica Vitti, wanting to experience the life of the workers, snatches a half-eaten bun from one of the striking workers.

If one compares the iconography of cinema with that of Christian painting, the worker is seen to be like that rare creature, the saint. Cinema does show the worker in other forms as well, however, picking up on the worker element present in other forms of life. When American films speak of economic power or dependence, they often portray this using the example of small- and big-time gangsters, preferring this to the scenario of workers and employers. Because the Mafia controls some of the labour unions in the USA, the transition from labour film to gangster movie can be a smooth one. Competition, trust formations, loss of independence, the fate of minor employees and exploitation – all are relegated to the underworld. The American film has transferred the fight for bread and pay from the factory to the main halls of banks. Although Westerns frequently deal with social battles as well, such as those between farmers and the ranchers, these are seldom fought in pastures or fields, but more frequently on the village street or in the saloon.

Even in the real world, social conflict does not usually take place in front of the factory. When the Nazis crushed the labour movement in Germany, they did so in apartments and neighbourhoods, in prisons and camps, but hardly ever in or in front of factories. Although many of the worst acts of violence of the twentieth century – civil wars, World Wars, re-education and extermination camps – have been closely linked to the structure of industrial production and to its crises, nev-

ertheless most took place far away from the factory setting.

1956: a British Pathé newsreel showed pictures of the class struggle in England. Striking workers at the Austin plants in Birmingham attempt to prevent strike-breakers from maintaining production. They try sit-down protests and turn to violence in order to stop components from entering or leaving the factory. They try to wrench open the door of a truck, to pull out a strike-breaker, but they do not punch him through the open window so as to make him open the door or give up his journey. Obviously this fight follows unwritten rules that limit the extent of the violence. The strikers act with passion, but without the desire to injure somebody or to destroy something. The workers' campaigns are almost always less violent than the ones carried out in their name.

I have gathered, compared and studied these and many other images which use the motif of the first film in the history of cinema, 'workers leaving the fac- tory', and have assembled them into a film, *Arbeiter verlassen die Fabrik* (*Workers Leaving the Factory*, video, 37 min, b/w and colour, 1995). The film montage had a totalising effect on me. With the montage before me, I found myself gaining the impression that, for over a century, cinematography had been dealing with just one single theme – like a child repeating for more than a hundred years the first words it has learned to speak in order to immortalise the joy of first speech. Or as though cinema had been working in the same spirit as painters of the Far East, al- ways painting the same landscape until it becomes perfect and comes to include the painter within it. When it was no longer possible to believe in such perfection, film was invented.

In the Lumière film about leaving the factory, the building or area is a container, full at the beginning and emptied at the end. This satisfies the desire of the eye, which itself can be based on other desires. In the first film, the aim was to represent motion and thus to illustrate the possibility of representing move- ment. The actors in motion are aware of this; some throw their arms up so high and when walking put their feet down so clearly, as though the aim were to make walking appear vivid for a new *orbis pictus* – this time in moving pictures.

A book dealing with pictures of motion could state, like an encyclopaedia, that the motif of the gate occurs in one of the first works of literature, *The Odyssey*. The blinded Cyclops at the cave exit feels the emerging animals, under whose bellies Odysseus and his followers are clinging. Leaving the factory is not a literary theme, not one which has been adopted by cinema from a visual- ised literature. On the other hand, one cannot conceive a filmic image which does

not refer to pictures from before the age of cinema – painted, written or narrative images, images embedded within the thought process.

By straying from the path we may discover something of this prehistory. Immediately after the command had been given to leave the factory back in 1895, the workers streamed out. Even if they sometimes got in each other's way – one young woman is seen to tug at another's skirt before they part in opposite directions, knowing that the other will not dare to retaliate under the stern eye of the camera – the overall movement remains swift and nobody is left behind.

That this is the case is perhaps because the primary aim was to represent motion, maybe signposts were already being set. Only later, once it had been learned how filmic images grasp for ideas and are themselves seized by them, are we able to see in hindsight that the resolution of the workers' motion represents something, that the visible movement of people is standing in for the absent and invisible movement of goods, money and ideas circulating in industry.

The basis for the chief stylistics of cinema was given in the first film sequence. Signs and symbols are not brought into the world, but taken from reality. It is as though the world itself wanted to tell us something. ▮

Translation by Laurent Faasch-Ibrahim
The English translation of this piece originally appeared in
NachDruck/Imprint (Berlin: Verlag Vorwerk; New York: Lukas
& Sternberg, 2001) and is published here with the kind
permission of the publisher.

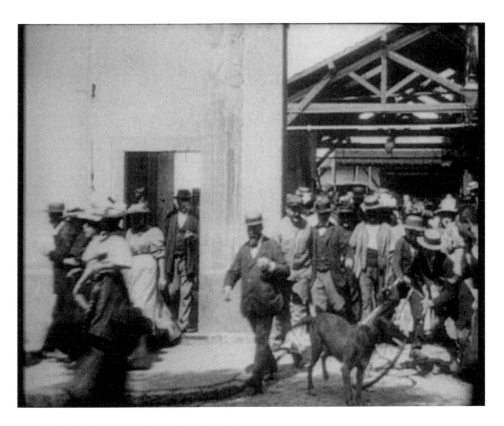

Workers Leaving the Factory © Harun Farocki, 1995

Workers Leaving the Factory
Harun Farocki

Workers Leaving the Factory – such was the title of the first cinema film ever shown in public. For 45 seconds, this still existent sequence depicts workers at the photographic products factory in Lyon owned by the brothers Louis and Auguste Lumière hurrying, closely packed, out of the shadows of the factory gates and into the afternoon sun. Only here, in departing, are the workers visible as a social group. But where are they going? To a meeting? To the barricades? Or simply home? These questions have preoccupied generations of documentary filmmakers, for the space before the factory gates has always been the scene of social conflicts. And furthermore, this sequence has become an icon of the narrative medium in the history of cinema. In his documentary essay of the same title, Harun Farocki explores this scene right through the history of film. The result of this effort is a fascinating cinematographic analysis in the medium of cinematography itself, ranging in scope from Chaplin's *Modern Times* to Fritz Lang's *Metropolis* to Pier Paolo Pasolini's *Accattone*! Farocki's film shows that the Lumière brothers' sequence already carries within itself the germ of a foreseeable social development: the eventual disappearance of this form of industrial labour.

Workers Leaving the Googleplex
Andrew Norman Wilson

Workers Leaving the Googleplex investigates the marginalised class of Google Books 'ScanOps' workers at Google's international corporate headquarters in Silicon Valley. Wilson documented the yellow-badged ScanOps workers while simultaneously chronicling the complex events surrounding his own dismissal from the company. The reference to the Lumière Brothers 1895 film *Workers Leaving the Factory* situates the video within motion picture history, suggesting transformations and continuities in arrangements of labour, capital, media and information.

Mark Leckey, Green Screen Refrigerator, (2010) Courtesy of the artist and Gavin Brown's enterprise, New York.

Dream Factory
Andrew Norman Wilson and Aily Nash

Considering the various modes of examining new forms of labour, consumption-as-production and the aesthetics and visual language of globalised 'lifestyles', artists' moving image and media work recapitulates corporate imagery and language as both a critique and recognition of the omnipotence of these systems. From videos that present the agency of objects in relation to consumers to the consideration of the space of labour through interventions into sites of emergent industries and globalised consumption, performative and farcical rhetoric, exaggerated uses of prosumer editing and motion graphics tools, and reverent appropriations of advertising imagery – these makers explicitly engage dream factory capitalism.

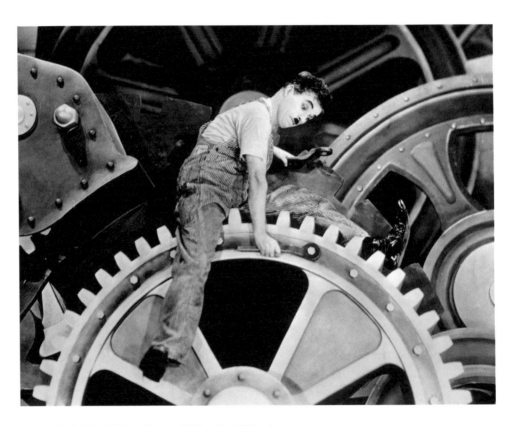

Charlie Chaplin Modern Times 1936 © SuperStock RM.

DOES
WORK

OR DO
YOU

SHAPE YOU

SHAPE WORK?

A Cinematic Time and Motion Study
Richard Koeck

Throughout its history, film has been used as an instrument to portray working-class lives, and has given provocative as well as entertaining insight into the social, economic and political climate of a particular time and place. In *La sortie de l'usine Lumière à Lyon* (1895), the Lumière brothers shot and later screened, to a paying audience at the Salon Indien du Grand Café, Paris, a series of films that showed some hundred workers leaving a factory for photographic goods in Lyon-Montplaisir. The evenly paced movement of the workers walking into off-screen space from the left and right still offers, today, room for speculation about how the films were produced[1] and raises questions of the light in which factory workers are shown in the film.

These short movies not only established the industrial proletariat as a visual trope for generations of filmmakers and cinema audiences to come, but also demonstrated the important narrative role played by the *space* that is portrayed on screen during these formative years of film and cinema. The spatial choreography of these commercial movies is remarkable and they are considered by some as an early form of narrative films.[2] In this case, factory workers progress towards the camera through carefully framed gates, leaving the *territory of work* and entering the *space of leisure time*.

At a time in which physical space is augmented, if not substituted, by digital public space, and our ability to share and access information at any time, almost instantaneously and in any place has begun to blur traditional spatial boundaries between work, life and leisure, it is perhaps a good moment to use film as a window through which we can reflect on how particular spatial environments have changed over time; in the real world and as filmic commentary in the cinema. This essay sketches a journey from the 'modern' to the 'postmodern' concept of 'being at work', from analogue to digital, through the lens of popular fiction film. Addressing issues such as Taylorism, territory and technology, it will show how cinema depicted, and

thus provided critical commentary on, the impact of modernism on architecture, the city and the way people interact, with inhabited spaces and places defined by our concept of work.

A Modern Workforce for Modern Times

Walter Ruttmann's Berlin: *Symphony of the Great City* (1927) is one of a series of so-called 'city symphonies' produced in the 1920s that portray a typical day, or 24-hour cycle, of a real or imagined metropolis.[3] Using montage as the preferred form of editing, filmmakers like Ruttmann were able to juxtapose discrete and rhythmic urban acts into an illusion of place, whereby ordinary citizens, pupils and office workers alike are bound to activities dictated by the modern metropolis. A recurring clock motif gives structure to the plot of the film, and also shows the city as a machine-like place that is rationally divided into functions and districts, each of which is under the same law of time.

While in Ruttmann's film the workforce arrive at their workplace by train in the morning, signified by horizontal movement of the train, Fritz Lang's workforce in the epic *Metropolis* (1927) travel vertically from their living quarters in the city's underground, depicted by the movement of an elevator. As such, Ruttmann implies an urban life in which class difference is visible yet seemingly unproblematic, as if the city, like clockwork, has a series of cogwheels that mesh together. By contrast, Lang's vision of a great city includes a working class that is clearly supressed in a space held together by strong leadership from Joh Fredersen (Alfred Abel). The blowing of a whistle signals the shift changes in the city's underground factories, where workers are forced to perform hard physical labour to the point of being sacrificed to the machine, Moloch.

Physical uniformity is the rule in this kind of city, and the faceless marching workers, identified only by numbers, are subsumed into the crowd. The crowd motif is, indeed, one that recurs in films of the 1920s and 1930s, such as King Vidor's *The Crowd* (1928). This film features not an implied American high-rise city as in *Metropolis*, filmed with miniature models in the studio, but shows, in segments, location shots of the real Manhattan. King Vidor's motion picture is visionary in many respects, and the film was released just before the Great Depression hit the streets of New York and the wider world. Its protagonist is not a factory worker enslaved by the machine, but a white-collar worker who, as long as he is willing to stand out from the crowd, can seemingly achieve anything in his career.

The city in the film, however, is also a place full of risk, and personal tragedy

outweighs the economic success and achievements of the main character. Vidor's film uses impressive low- and high-angle trick photography which reveals unusual perspectives of the city and juxtaposes its wider territory, animated by thousands of people, cars and trains, with the life of an individual office worker, John Sims 137 (James Murray).

inema's own time nd motion study heds an interesting ght on the innate ncertainties elating to the rapid nechanisation f a modern urban festyle

How close the boundaries lie between the extreme ends of social classes is shown in René Clair's comedy, À nous la liberté (1931), which tells the story of Louis (Raymond Cordy) and Émile (Henri Marchand), two escaped convicts whose lives outside prison take them in entirely different directions. While one ends up a poor vagabond, the other becomes a rich industrialist managing a phonograph factory. Here the architecture in the film is more than passive backdrops. Lazare Meerson's art deco-inspired set designs for the prison are used to capture the 'uniform starkness, linearity and geometric angles; the regimentation of the inmates as a narrative extension of space, in which form is inextricably linked to function'.[4] Interestingly, Clair uses modern design elements as an indictment of personal imprisonment and capitalism, yet the film was produced at a time when architectural modernism was celebrated in France and across much of Europe.[5]

However, it is perhaps Charlie Chaplin's masterpiece, Modern Times (1936), whose opening scenes of a factory production line incidentally show remarkable similarities to Clair's film, that has become the visual icon for the shortcomings of a mechanised modern society. In Chaplin's masterly way, he uses humour to point a finger at the intrusiveness and absurdities of the scientific management of workers (Taylorism) and the industrialised and standardised mass production of goods (Fordism).

While in William Cameron Menzies's The Shape of Things to Come (1936) technological progress was seen as a driving force behind a peaceful society, after the Second World War cinema became more sceptical of scientific innovation. In 1951, for instance, Ealing Studios produced the satirical comedy The Man in the White Suit, directed by Alexander Mackendrick. The film's protagonist, talented

researcher Sidney Stratton (Alec Guinness), invents a bright white suit made from everlasting chemical fibre and radioactive elements, but turns from a celebrated hero to villain when industry leaders, trade unions and ordinary workers realise the damaging impact of his invention for the textile industry. The film ends poignantly, with the inventor being chased through the streets of night-time London, and shows that modern times require a modern workforce. Cinema's own study sheds an interesting light on the innate uncertainties relating to the rapid mechanisation of a modern urban lifestyle.

Spatial Encounters between Humanity and the Electronic Brain

The perception that computers might not only have positive effects on a worker's life was articulated in cinema as early as in the mid-1950s. The Twentieth Century Fox production *Desk Set* (1957), with an unforgettable lead cast directed by Walter Lang, shows how two so-called 'electronic brains' threaten the authority and efficiency of reference librarian Bunny (Katharine Hepburn) and her team. Interestingly, the 1950s office seems to be firmly the spatial domain of a female workforce, which the film shows to be challenged by the invasion of early computers, naturally introduced by a male efficiency expert (Spencer Tracy) to a mystified staff. When challenged, Bunny and her team resist the new innovation and are proven right by the end of the film.

A belief in efficiency and cost-saving led to architectonic consequences in the late 1950s and 1960s, and saw the creation of buildings and spaces that left much to be desired. Jacques Tati's comedy, *Mon Oncle* (1958), sheds critical light on the difference between traditional and modern ways of life, highlighting the apparent inefficacy and absurdity of modern design solutions on a domestic scale. The industrialist is, in Tati's film, ridiculed as a decadent anti-hero who is subjugated by quasi-advancements and life in a world made from plastic. Tati followed this theme on an urban scale in *Playtime* (1967), where the disoriented Monsieur Hulot (played by Tati) battles with non-penetrable glass architecture; a city that was seemingly designed with Corbusian scientific rationalism yet becomes a strange world in which tourists and office workers alike behave in utterly unreasonable ways.

In the same cinematic time period we see Stanley Kubrick's masterpiece and cult science fiction film, *2001: A Space Odyssey* (1968), where scientists are freed from gravity, suspended in outer space and working effectively in solitude alongside a company of artificial intelligence, the spaceship's computer HAL 9000. Kubrick

delivers an ambiguous and disturbing plot, and the computer, which controls the spaceship's operations, appears to have developed emotions which have far-reaching consequences. As HAL feels that its own existence is potentially compromised by humans, he suddenly turns off life-support functions and takes control of the spaceship's capsule and, therefore, the only space in which the crew can survive.

The idea that the world's future workforce needs to be genetically perfect is explored by Andrew Niccol's near-future film, *Gattaca* (1997), as well as in a series of subsequent science fiction films, including *The Island* (2005) and *Surrogates* (2009). Here, humankind needs a workforce that is optimised by pre-implantation genetic diagnosis and later registered in biometric databases, dividing humanity into those who are genetically without flaw and those who are inadequate for certain tasks. In *Gattaca*, Vincent (Ethan Hawke), with forged DNA samples, manages to work for a spaceflight corporation and dreams of being selected for a manned spaceflight to Saturn's moon, Titan.

Filmed in part at Frank Lloyd Wright's Marin County Civic Center (1960–62), San Rafael, California, it uses modern architecture as the spatial backdrop of a dystopian future in which genetic determinism and eugenics are accepted ideologies.[6] Again, an 'electronic brain' not only stores all human data, but also grants a uniform workforce access to, via a blood-sampling DNA recognition system, highly secured corporate offices.

Spatial Ambivalence in the Office: Questioning Known Territories

Nearly 30 years after its production, Terry Gilliam's *Brazil* (1985) has lost nothing of its topicality and relevance. Recalling George Orwell's novel, *Nineteen Eighty-Four* (1949), Gilliam visualises a highly bureaucratic and totalitarian government that, despite everything seemingly being accounted for, stumbles over its own dogmatic system and eventually goes out of control. Due to a simple misspelling of a file name, the government mistakenly incarcerates and subsequently kills Archibald Buttle (Brian Miller) instead of the suspected terrorist Archibald Tuttle (Robert De Niro). Sam Lowry (Jonathan Pryce), a lowly government employee and main protagonist of the film, is shown moving into his new office when a neighbouring officer pulls his desk through the wall.

Brazil paints a grotesque picture of a dictatorial society where, despite being technologically advanced, nothing is stable or reliable. Arbitrariness rules the world and concrete architectural spaces are used in perplexing ways. In one unforgettable scene, a leading officer, Mr Warren (Ian Richardson), makes snap decisions while

walking quickly down a corridor, randomly shouting 'yes' and 'no' to questions posed by a milling mob of 'expediters' following in his wake.[7]

While *Brazil* warns us that bureaucracy can undermine our societal rights and values, Joel Schumacher's *Falling Down* (1993) grants the audience an intimate look into the mind of a typical American corporate employee. On a hot summer day, stuck in a typical Los Angeles traffic jam, the world of William Foster (Michael Douglas), a divorcé and unemployed defence engineer, begins to fall apart. On leaving his known territory, that of the office and car, Foster runs into a serious conflict with a Korean convenience store owner and, later, two members of a gang. Dressed in typical white shirt, with rimmed glasses and briefcase, Foster is clearly *out of place* when the gang accuses him of trespassing on their ground. Foster's attempt to reason with the gang ends in violence, with this extract from the dialogue perhaps showing why:

> This is a gangland thing, isn't it? We're having a territorial dispute? I've wandered into your pissing ground or whatever the damn thing is...and you're offended by my presence. I understand that. I mean, I wouldn't want you people in my back yard, either.

With L.A. architectural iconography in the background, Douglas's character is becoming an urban combatant, equipped with a baseball bat, shotgun and later even a rocket launcher: welcome to the corporate world of 1990s Los Angeles. *Falling Down* characterised the present-day man whose role in society, his personality and view of himself is linked to his profession. Once this man loses his job, the presumed equilibrium between the inner and outer world, a quasi-work–life balance comes to a sudden end.

Spike Jonze's comedy, *Being John Malkovich* (1999), goes one step further and undermines a worker's terrain – an ordinary high-rise office. Craig Schwartz (John Cusack) discovers that his office, in the Mertin Flemmer Building, New York City, has an unexpected 7½ floor, which he finds hidden behind a filing cabinet. This door acts as a portal into the brain of actor John Malkovich and anybody that enters the door can, for a short period of time, live in the mind of Malkovich, see through his eyes and partially control his actions before being ejected into a ditch near the New Jersey Turnpike. The film also shows what would happen if Malkovich entered his own mind portal, a situation that might be familiar to a lot of people today who manage real and virtual profiles simultaneously.

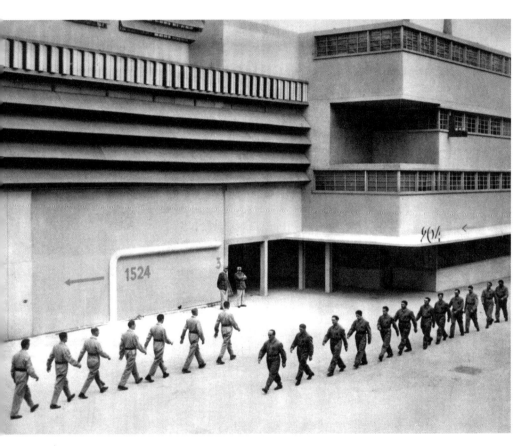

À Nous la Liberté, 1931. Courtesy of Ronald Grant Archive / Mary Evans

The Mediatisation of Work Environments

Remembering the Lumière brothers' factory workers walking towards us through the factory gates before leaving the frame of the picture to the left and right, it is clear that the same workers today would not walk into a free world as imagined over a hundred years ago. Working and work environments no longer start and end at factory gates. 'Being at work' is not a spatial act confined to a single place; it has been mediatised and has conquered almost every corner of our existence.

While most of our corporate office buildings do not have a 7½ floor, it is noticeable that in the last decade, TV producers have found considerable entertainment value in dramatising ordinary day-to-day lives in corporate offices. A new trend started with Ricky Gervais and Stephen Merchant's TV comedy *The Office* (2001–03) in the UK, its US version (2005–13) and several other TV series that followed in its trail, such as the US productions of *Workaholics* (2012–) and *Men at Work* (2012–). We seem to find pleasure sitting at home on our couches, relaxing from a hard day by watching our alter egos suffering at work.

Being at work is, therefore, not easily separated from leisure activities, and computer games invite us to check virtual e-mails inside fictional gaming worlds, such as in *Grand Theft Auto IV*'s Liberty City which closely resembles New York City. Users might feel that they lower their achievement points, or even blow their mission, by not answering virtual phone calls or messages left on virtual answer machines. Similarly, in SimCity, an agent-based simulation game, users assume an avatar, build cities and scenarios that resemble real-life situations such as 'going into work' or, for that matter, 'going to a cinema'.

All this demonstrates that traditional boundaries between work and life are fundamentally undermined, as we all know, but do we mind? While in the past, work environments had a particular spatial territory and were therefore open to being challenged, such as by the computer as in the film *Desk Set*, today they are spatially independent – fluid, mobile, virtual and outside the traditional, modern conventions of time and motion. ∎

1 H. Farocki, Working on the Sight-Lines (Amsterdam: Amsterdam University Press, 2004): 239.
2 A. Gaudreault, From Plato to Lumière: Narration and Monstration in Literature and Cinema, trans. Timothy Barnard (Toronto: University of Toronto Press, 2009): 28.
3 Other well-known 1920s city symphonies include Manhatta (C. Sheeler, 1921), Man with a Movie Camera (D. Vertov, 1929) or Regen (M. Franken, J. Ivens, 1929).
4 T. Bergfelder, S. Harris and S. Street, Film Architecture and the Transnational Imagination: Set Design in 1930s European Cinema (Amsterdam: Amsterdam University Press, 2007): 186.

5 The resistance to modernism as a style was greater in the UK compared to other countries. It arrived a few years later when leading figures came as political émigrés to the UK.
6 D.A. Kirby, 'The New Eugenics in Cinema: Genetic Determinism and Gene Therapy in Gattaca', Science Fiction Studies 27 (2000): 193–215.
7 The term 'expediters' is mentioned in the original script for the film.

DID YOU
CHECK

BEFORE
GETTING

YOUR PHONE

OUT OF BED?

Mind Over Media
Bronać Ferran

Often that is what artists do: they shake you sufficiently to break your transparency, and let you come back to who you are.
J. Varela [1]

As we advance into the twenty-first century, understanding of mind and media and their constitutive relations is growing. Moving beyond the provocations of performance and live art with which we are now familiar, online representations of body parts and images of private zones are despatched in streams of improvisatory movements, feeding growing demand for more and more intimate, extensible media experiences.

We move in accelerated ways between mind and media. Add-ons, plug-ins and other apps are pushed at us on-screen, like ingredients of new life forms. In order to survive we have to adapt and evolve, as proponents of systems art have known for decades. Current popular applications like Snapchat, transitory and dialogic, allow us to playfully represent ourselves and others, enabling instantaneous reflection in the eye of the receiver, producing assurance of rapid feedback combined with a promise of machinic erasure.

In this way, understanding of mind and media and their mutual correlation is evolving in the early twenty-first century. In this essay I reflect on the contagious nature of today's technologically enabled creativity and its relationship to pioneering art works from when the information age was new. I note current trends towards rebalancing the intensity of engagement in media (and its distractions) with embodied cognition and reflective mind, showing how artists are helping us return to our senses.

The web, once virgin territory for early moving artist-pioneers of electronic media, has become a carnival of masks and masquerades: a battleground, a playground where still no one has quite defined the rules – and business is nudg-

It is understood that we receive far more information than our organic selves can process

ing ahead of the web ethos of collaboration, appropriating it to entrepreneurial ends. An English schoolboy I have heard about, not yet doing GCSEs, earned £20,000 last year providing a subscription-based server for (often young) people playing *MineCraft* around the world, his venture supported by a team of coders who he has never met and who give their time free in exchange for game privileges. It beats *Blue Peter*.

Machine time, out of sync with the speed of our embodied cognitive selves, drives us along: mobile devices in hand, both waving and drowning. We are up to our eyes in information, or least in data. Perhaps we need new eyes as Marcel Proust once suggested – or maybe just a better way of looking.

Channelling Cognition

In *Machine Times* (2000), a catalogue produced for a millennial exhibition in the Netherlands, Mark C. Taylor tells us how 'information is not merely what is in the computer and transmitted over various networks' but also 'distributed through all biological, chemical and physical processes'.[2] Rebecca Solnit, writing recently in the *London Review of Books*, worries that Google already has plans to channel our cognition through invention of its Glasses, which having tested she feels 'will chop our consciousness into small dice' and make real the 'interrupters that Vonnegut thought of as a fantasy evil for his dystopian 2081'.[3]

Solnit reflects on a 'bygone time' which 'had rhythm, and…room for you to do one thing at a time' and on 'how a restlessness has seized hold of many of us, a sense that we should be doing something else, no matter what we are doing'.[4] She is here pointing to the problem of distraction and disruption which has become a consistent challenge in our working lives today. The Internet is an appealing site of heterochronia: we can move inwards and out of time. With the tools of hyperlink and cut and paste we can build ready assemblages that traverse and integrate hitherto distant connections. But the rhythm, if there is one, is of break-beat and disjuncture.

Finding the Info Beat

Neuroscience is now offering important insights into the different temporal characteristics of mind and body, of our cognitive and motor faculties. In *Machine Times*, neurologist Detlef B. Linke explains how 'people are always in search of synchrony and rhythmicity' and that the brain 'is constantly setting up expectations which include certain anticipations of rhythm'.[5] He adds that 'to fully delight the entire brain, it must always contain the odd syncopation or occasional diversion', and overall for a human brain to function effectively it helps for it to find what he calls 'the information beat'.[6] He also explains that we receive far more information than our organic selves can process, especially as our cognitive and motor faculties have very different temporal characteristics, that is, they run at different speeds.

One senses that artists often know this stuff instinctively or learn to manipulate it in learning their trade: they get with the beat, make it and break it. Through sensitive cognitive embodiment and expression within artworks, they may manage, as Virginia Woolf hoped, 'to achieve in the end some kind of whole'.[7]

Anticipatory Works

Norbert Wiener, founder of the science of cybernetics upon which our contemporary communications infrastructure depends, identified in 1960 the problems inherent in the relations between the human mind and the machine telling us that 'by the very slowness of our actions, our effective control of our machines may be nullified' and instructing us to 'remember that the automated machine...is the economic equivalent of slave labour'.[8]

Marshall McLuhan, theorist of the emerging Information Age in the 1950s and 1960s, closely echoed this in his infamous *Playboy* interview in 1969: 'If we understand the revolutionary transformations caused by new media, we can anticipate and control them: but if we continue in our self-induced subliminal trance, we will be their slaves.'[9] Having been close to Wyndham Lewis, founder of Vorticism and also regular correspondent with Ezra Pound, a brilliant innovator but discredited politically, McLuhan was convinced that one of the often misunderstood roles of artists was 'subliminally sniffing out environmental change', seeing 'alterations in man caused by a new medium', using their work to draw attention and 'prepare the ground for it as he explained further in the same interview'.[10]

In *Machine Times*, Douwe Draaisma, a psychologist, agrees that artists 'sometimes show a seismic sensitivity to latent fears in society' and 'find an expression for phenomena which are still hidden from view for most of us', a view

expressed even earlier by Gino Severini, an artist who had belonged to the Italian Futurist movement, writing in 1946:

> Today poets and painters are striving to bring to the surface of their being things which once lay within them almost like a dream. Becoming aware of self, the notion of self, is one of the great laws of the development of man in history, and it affects the work of the spirit and concerns culture and art in a special way. The 'discovery of one's inner self' as Maritain would put it, is part of a natural need felt by the artist who seeks to have an even deeper awareness of his art, especially when great historical periods are in preparation or new cultural and social conditions are in formation which will bring new 'media' of expression... The history of people and civilizations is written by their art and not by their economics and industries and policies.[11]

Note Severini's very early reference to 'new "media" of expression'.

Growing Awareness

Artists began seriously thinking about working with information technologies, kinetic and automated machines in the period between the mid-1940s and the end of the 1950s when the first pioneering works began to emerge. They were heavily informed by the backdrop of the Cold War, the ravages of the Second World War in recent memory, and an emerging counter-cultural mindset that posited techniques of chance and randomness against control and the machine.

Gustav Metzger, a pioneer of techniques of machine art, auto-destructive and auto-creative art, along with Jean Tinguely and Brion Gysin, created several extraordinarily groundbreaking works between 1959 and 1961, playful, enquiring, experimental, adaptive, constructive, destructive, creative. These have acted as foundation stones for many later works, with themes and threads that also emerge within twenty-first-century innovation management manuals trumpeting the vital importance of creative destruction.[12]

The works of these artists – breaking with composition, diluting subjectivity and enabling the intervention of chance into both conceptual development and eventual audience engagement – fulfilled what McLuhan called at the time making 'counter-environments'. In *Art and Its Objects*,[13] art historian Richard Wollheim defined a work of art as a form of life: a term which appears very appropriate both for antecedent works by twentieth-century artists exploring open, generative and

Being in a state of not knowing is a condition many artists need when they begin to develop new works deep within their subconscious

collaborative approaches, which in turn have directly influenced artists working in emerging fields now like synthetic biology, bio-art projects, live coding and so on. It was also appropriate for the work of the Generative Art Group – GAG – founded in 1972, who advertised their work a year later as being about 'open-axiomatic artforms, individually creating potential units which could be arranged accordingly to each other, becoming components of a conjunctive structure-context, a whole with its own life, a self-regulating system of suggestions and transformations, the innate activity of the group is a reciprocal propensity'.[14]

Brian Eno, pioneer of generative art processes as well as electronic and ambient music, wrote 'Music for Airports' in 1979. A letter he sent to the Venice Biennale curators in 1986 (displayed in an archival exhibition there in 2013) recounts a less harmonious airport experience revealing challenges in defining the work of art:

> The tools and tapes I brought with me have been seized at customs: the first reason given for this seizure was that I was carrying artworks. I explained that these were components and tools. Today I learnt that the reason given today is that my luggage contains items by the Red Brigade. Nobody knows what these items are.[15]

Resting State

In terms of methods and artistic techniques, being in a state of not knowing is a condition many artists need when they begin to develop new works deep within their subconscious brains. The importance of periods of deep thinking or not thinking is not easily prescribed within often positivist theories of creativity. Similar problems may emerge within knowledge engagement frameworks which inevitably lack metrics for the benefits of states of unknowing – or accounting for how solid works of art develop from what artist David Kefford has called 'deep dollops of doubt'.[16]

Virginia Woolf, writing in her diary about the development of her novel *The Waves*, would have concurred:

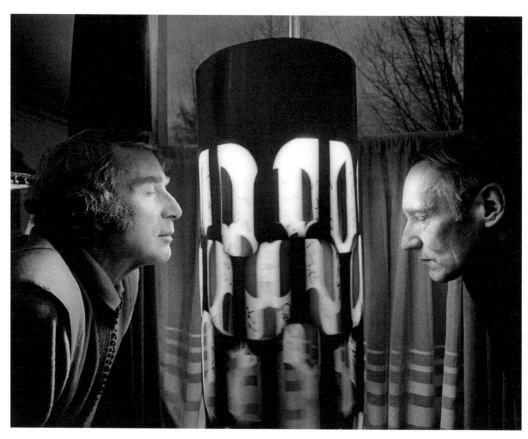

William S. Burroughs, Brion Gysin and Dream Machine. Courtesy of Charles Gatewood

If I could stay in bed another fortnight (but there is no chance of that) I believe I should see the whole of The Waves... I believe these illnesses are in my case...how should I express it? – partly mystical. Something happens in my mind. It refuses to go on registering impressions. It shuts itself up. It becomes chrysalis. I lie quite torpid...then suddenly something springs.[17]

Some researchers in sleep and brain research have concluded that working from one's bed and even sleeping on the job can be beneficial from the viewpoint of the creative imagination. A well-established theory in brain research tells us that each of us within our heads has an area called a 'global workspace', which Donald J. DeGracia's research connects to dreams and creative thinking: 'Dreaming results in a "mental recombination" of cerebral information networks, which contributes to the ability of the waking consciousness to generate novel and adaptive responses.'[18]

French artist Virgile Novarina[19] has actively investigated this workspace. When he was a student of maths and physics, worrying about 'wasting' eight hours each night when he could be working, he taught himself to wake from deepest sleep and to immediately record what he remembered of his dreams through drawings and writing fragments. This process was so successful he now gets commissioned, by galleries and festivals, to go to sleep somewhere visible at night, for example in a gallery or shop window or a bar, and to wake, document and share in the morning the entrails of his night's activity.

Sleep art and media has also become a lucrative marketing technique for a French hotel chain which has installed a bed with sensors that measures the movements, breathing vibrations and other actions of its sleeping guests. Initially in 2012, this was for a 'robot-artist', as they termed it, to create a live picture in the foyer of the data received; and in 2013 for a smart phone app that reproduces a visualisation of rhythm and movement (they call it an 'artwork') to be posted to social media.[20]

The Business of Mind

Selling techniques for achieving a resting, idling and meditating mind are becoming big business in an age of multiple information inputs and intensive distractions. There are many mindfulness groups within workplaces and community contexts around the world, but the news announced in spring 2013 that Google was offering free mindfulness classes to its staff, to enhance the empathetic capacities of its engineers, attracted some attention. Mindfulness is the Buddhist state of focus

attained through meditation: with an emphasis on breathing it can be beneficial in situations of stress.

This connects well also with Google's Global Brain[21] project powered by its massive and ever-improving search capability. This avails itself of quantum computing that moves beyond binary zeros and ones into a both on and off 'in-between-ness' state[22] in a world where each of our movements online using Google software is captured and held, possibly for all time, and time ever after, like a Buddhistic infinity unfolding now. In an excellent critique, Kevin Healey has pinpointed the irony involved in companies who manufacture the tools of distraction having lessons in how to avoid it. In his view, from a 'bubble of integrity' they 'externalise the problems of fragmentation and distraction'.[23]

Along with mindfulness, distraction is trending. Marisha Pessi makes creative capital of this with *Night Film*, her recent novel laid out in part like a social media page and riddled with references to Twitter and Facebook which her readers access while reading the story. The narrative contains 'interactive touchpoints' embedded within the paper which buying an associated app will help to unlock.[24]

Two artists in London have come up with a perfect composite, a project they have called *Mindful Distractions*. The new work by London Fieldworks, Bruce Gilchrist and Jo Joelson, will encourage awareness of the productive capacity of the idling brain in its resting state, a notion that will appeal to those of us who often seem to gaze into the distance and seem to be doing nothing. They often represent in their work what they call the poetics of data. In one of their recent works, a robot, programmed by software drawn from EEG readings from the brain of Gustav Metzger, the octogenarian pioneer of auto-creation, sculpted a void in stone.

A few years ago, the two artists went to sleep in public in specially constructed tubes each day for six days at the Roundhouse in London. They saw themselves as 'lab rats' allowing geneticists to work beside them on benches taking samples of their blood at regular intervals for the project, which was investigating the impact of shift-working and disrupted sleep on the effectiveness of mind and body. A further strand of this research project, Hibernator, supported by an AHRC Fellowship award, used then-leading-edge green screen technologies to animate the figure of Walt Disney, who has been long rumoured to have asked for his body to be put into cryogenic storage after death for a future reawakening.[25]

Having once threatened to disembody us, technology is bringing us back to our senses, moving at speed from hardware on our desks to mobile media in our pockets, to devices allowing us to touch time on the pulses of our wrists. So it will

continue to mesh, graft and embed with the networks, circuits and vibrations of our bodies. Neuroscientists are sending microchips into brains to help paraplegic patients regain movement [26] while inventive young designers like Bare Conductive in London are ahead of industry innovation curves with their bio-conductive ink that 'bridges the gap between electronics and the body'.[27]

Citing Nobel Prize-winning physicist Murray Gell-Mann, John Howkins proposes that the most important resource in the twenty-first century 'is a "synthesising mind" which can decide what is important, rejecting everything else'. His book *Creative Ecologies*, argues eloquently that 'thinking is a proper job'.[28] Our capacity to synthesise and find novel connections is also aided, it would seem, by time spent dreaming. With artists to lead the way, we can all reap the benefits of working overtime in slippery zones between mind and media. ▪

1 'From 'Deep Now, An Interview with Francisco J. Varela by Arjen Mulder', in *Machine Times* (Rotterdam: NAI/V2, 2000):20.
2 From 'An Interview with Mark. C. Taylor by Arjen Mulder: We Are the Incarnation of Complex Worldwide Webs', in *Machine Worlds*: 49.
3 Rebecca Solnit, 'Diary', *London Review of Books*, www.lrb.co.uk/v35/n16/rebecca- solnit/diary (accessed September 2013).
4 Solnit, 'Diary'.
5 Detlef B. Linke, 'The Rhythms of Happiness', in *Machine Times*: 29–43.
6 Linke, 'Rhythms': 30.
7 Virginia Woolf, notebooks from 1908, cited in Quentin Bell, *Virginia Woolf: A Biography* (London: Hogarth Press, 1972): 138.
8 Norbert Weiner, 'Some Moral and Technical Consequences of Automation', www.nyu.edu/projects/ nissenbaum/papers/Wiener.pdf (accessed September 2013). Originally published in *Science*, NS, 131.3410 (1960): 1355–58.
9 Marshall McLuhan, interview with *Playboy*, 1969, www.cs.ucdavis.edu/~rogaway/classcs/188/spring07/ mcluhan.pdf (accessed September 2013).
10 McLuhan, interview.
11 Gino Severini, 'Art and Money', in Gino Severini, *The Artist And Society* (London: The Harvill Press Limited, 1946): 63.
12 'Machine, Auto-Creative, Auto-Destructive Art', Ark, RCA (Summer 1962).
13 Richard Wollheim, *Art and Its Objects: An Introduction to Aesthetics* (New York: Harper and Row, 1968). Essay at http://emc.elte.hu/~hargitai/mmi/upload/wollheim3.pdf (accessed September 2013).
14 Generative Art Group description in News section of International Artists Cooperation mini-booklet, no. 8, 1973.
15 Letter from Brian Eno to Venice Biennale Festival organisers, www.labiennale.org/doc_files/vmi-presskitpdf.
16 David Kefford, artist, co-founder of Aid n' Abet, Cambridge, in conversation with author, September 2013.
17 Virginia Woolf, excerpt from diaries, cited in Bell, *Virginia Woolf*: 149.
18 http://awakenvideo.org/pdf/InnerSanctum/CollectionVo-llA-G (accessed September 2013).
19 Virgil Novarina, http://archive.org/details/BaladeParadox-ale; http://www.hucleux-lefilm.com/ index_en.html (accessed September 2013).
20 www.dvice.com/2013-3-31/app-turns-your-sleep-patterns-personalized-works-art (accessed September 2013).
21 Google World Brain: www.worldbrainthefilm.com.
22 Google quantum: www.dailymail.co.uk/sciencetech (accessed September 2013).
23 Kevin Healey, http://nomosjournal.org/2013/08/searching-for-integrity (accessed September 2013).
24 http://marishapessl.com/decoder-app (accessed September 2013).
25 www.londonfieldworks.com/projects/spacebaby/gallery. php; www.domuswob.it/en/interviews/2013/02/20/null-object.html; www.londonfieldworks.com/projects/hiber-na-tor (all accessed September 2013).
26 www.technologyreview.com/news/508641 (accessed September 2013).
27 http://Youtube.com/watch?v=cCYn7oQILiA; www.bareconductive.com; www.rca.ac.uk.
28 John Howkins, *Creative Ecologies – Where Thinking Is a Proper Job* (St Lucia, Queensland: University of Queensland Press, 2009): 38.

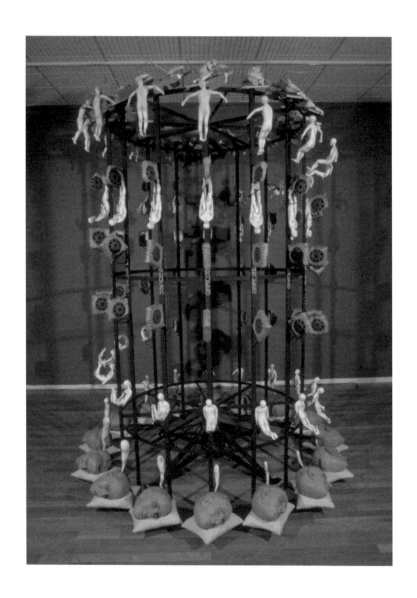

Gregory Barsamian
Die Falle

Taking on the visual illusion known as 'persistence of vision', Barsamian's work, *Die Falle* (German for *The Trap*), is a large-scale zoetrope of a man's reality in dream-time. The sculptures are perceived in real time but appear within a dream world. Our sensory world and our logic are in conflict: is it dream v. reality or reality v. dream? We not only fill the gaps between the movements of the sculptures, but between the conscious and unconscious state. Familiar objects face alternative realities and Barsamian's sculpture allows us a glimpse of the shadowy dream world that we want to escape from – *The Trap* – by bringing it into our waking perceptions. Rationality is left behind and we descend into a world of uncertainty, perceiving the fine line between reality and illusion.

Ellie Harrison
Timelines

For almost five years Ellie Harrison documented and recorded information about nearly every aspect of her daily routine as part of her artistic practice. These laborious, demanding and introverted processes grew ever-more extreme until she devised the ultimate challenge in 2006 for *Timelines* – to attempt to document everything she did, 24 hours a day, for four weeks.

The *Timelines* project was motivated by Ellie's overwhelming feeling that she was 'always at work'. It was to be an empirical study – monitoring exactly where all her time was going – to find out whether this was indeed true. What had seemed like a simple proposition quickly became an all-consuming ritual in which she was forced to take on the dual role of 'observer' and 'observed'. On the first day she confessed that 'It was horrible feeling so trapped – I couldn't do anything without generating and accumulating data', and so she rationalised the experiment by categorising her time into 17 possible activities such as 'art practice', 'domestic work' or 'leisure'. Each day the data was transferred onto an expansive spreadsheet, by the end of the four weeks it contained 2297 entries, which were then transposed into a series of 28 colour-coded timelines.

Shortly after the completion of *Timelines* Ellie quit 'data collecting' and entered into a period of self-reflection and re-invention in order to develop a 'healthier and more outward-looking practice'. Ellie emerged from this process with a far greater awareness of her role as a cultural producer within a wider economy. She realised that the feelings she was experiencing of a state of continual labour were not just an isolated case, but were in fact symptomatic in growing trends in the global labour market, which have arisen from advances in information technology and strategic policies to promote the freelance lifestyle.

Recent projects have seen her actively draw attention to and attempt to counteract the negative side-effects of this 'privatisation of work' – both the isolation and the unregulated and increasingly longer working hours – within a wider community of creative practitioners. Small personal experiments such as her 2012 *Email Detox* have enabled her to remain vigilant over her own time and rebalance her relationship between life and work when necessary.

Image overleaf

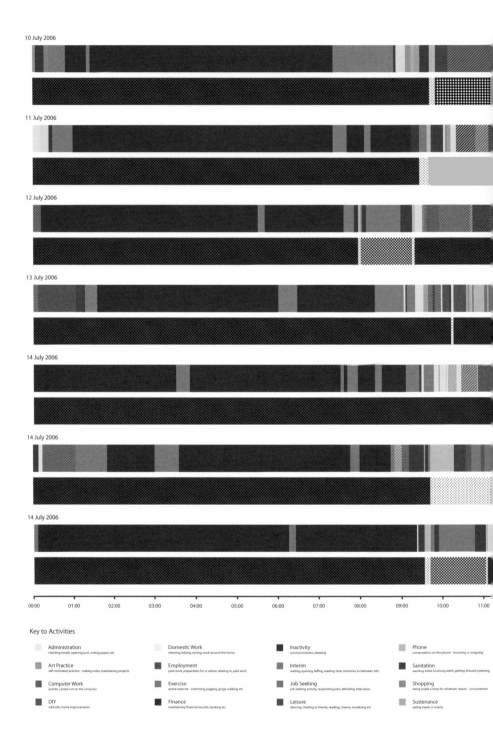

10 July 2006

11 July 2006

12 July 2006

13 July 2006

14 July 2006

14 July 2006

14 July 2006

00:00 01:00 02:00 03:00 04:00 05:00 06:00 07:00 08:00 09:00 10:00 11:00

Key to Activities

Administration
checking emails, opening post, sorting papers etc

Domestic Work
cleaning, tidying, sorting, work around the home

Inactivity
unconsciousness, sleeping

Phone
conversations on the phone - incoming or outgoing

Art Practice
self-motivated practice - making notes, maintaining projects

Employment
paid work, preparation for ur admin relating to paid work

Interim
waiting, queuing, faffing, wasting time, insomnia, in-between bits

Sanitation
washing, toilet, brushing teeth, getting dressed, preening

Computer Work
activity carried out on the computer

Exercise
active exercise - swimming, jogging, gorge walking etc

Job Seeking
job seeking activity, researching jobs, attending interviews

Shopping
being inside a shop for whatever reason - consumerism

DIY
odd jobs, home improvements

Finance
maintaining financial records, banking etc

Leisure
dancing, chatting to friends, reading, cinema, socialising etc

Sustenance
eating meals or snacks

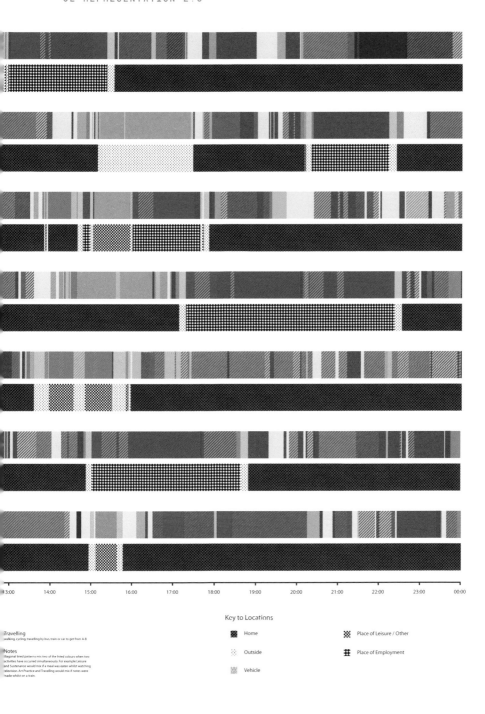

Key to Locations

Travelling
walking, cycling, travelling by bus, train or car to get from A-B

Notes
Diagonal lined patterns mix two of the listed colours when two
activities have occurred simultaneously. For example Leisure
and Sustenance would mix if a meal was eaten whilst watching
television. Art Practice and Travelling would mix if notes were
made whilst on a train.

- Home
- Outside
- Vehicle
- Place of Leisure / Other
- Place of Employment

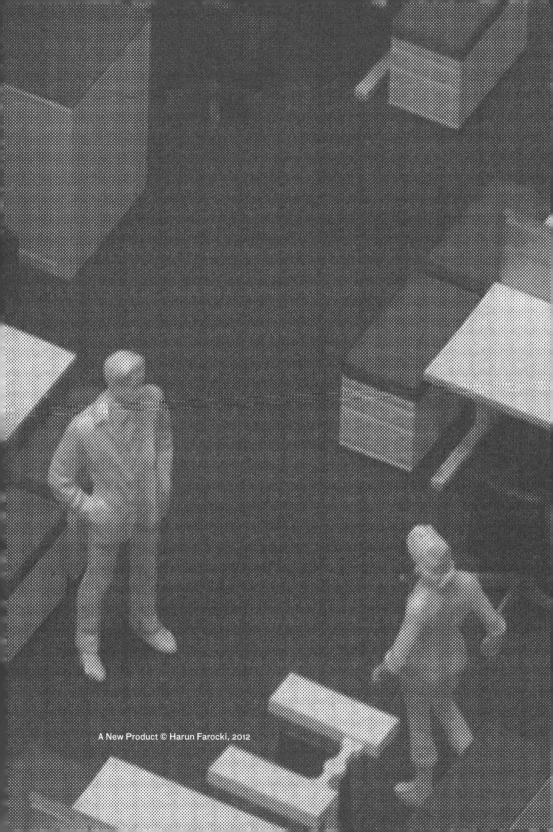

A New Product © Harun Farocki, 2012

WHERE IS
YOUR

WORK
PLACE?

Sensors and Serendipity in Architectural Space

Jeremy Myerson and Philip Ross

Current digital disruption to the architectural workplace is hardly a bolt from the blue. In fact it belongs to a continuum of change stretching back centuries: from the spinning jenny to the silicon chip, new technologies have always been a primary force in reshaping the physical places and spaces of work. If we'd been writing this essay one hundred years ago, we would have been describing a series of new industrial technologies, among them the elevator, electric light bulb, adding machine, typewriter and telephone, and explaining how their combination was creating a purposeful new environment for working in the twentieth century.

New digital technologies and mobile devices are forcing all organisations to ask afresh what office buildings are really for

We would have been examining the 'efficiency' manta of scientific management, as pioneered by Frederick Taylor, the godfather of time and motion. It was Taylorism that stripped nineteenth-century office clerks of their ornate, high-sided roll-top desks, which signified a master of his own domain, and reduced them to cogs in a machine constantly exposed to the suspicions of a supervisor.[1] Never forget that Le Corbusier, in eulogising about the modern world from the vantage point of the mid-twentieth century, chose 'admirable office furniture' as a subject for special praise in *Towards a New Architecture* (1946),[2] as rational workplace interiors became emblematic of the best of modernist thinking.

However we're writing this essay in the early years of the twenty-first century and the changes we face in the workplace are no longer analogue and linear. New digital technologies and mobile devices, together with ubiquitous connectivity, are

forcing organisations to ask afresh what office buildings are really for. The physical containers for work are today full of people carrying pieces of technology that enable them to operate independently of place. The speed and complexity of Internet transactions threaten to render the mundane human interactions across the office floor redundant. The 'death of distance', as predicted by the economist Frances Caincross,[3] presents an alternative model to the daily commute.

These digital fundamentals form an essential paradox in the familiar physical world of work. Yet we are still constructing large office buildings around the world. Organisations of all types are still leasing their floors and filling them with desks, equipment and people. Such buildings still constitute a giant presence in our urban centres, even if not all are as destructively overpowering as Raphael Vignoly's Walkie Scorchy building in London, which on a sunny August day in 2013 melted a Jaguar parked on the pavement outside.[4] For architects and designers who shape and plan the physical spaces of work, the question of what happens when new digital technologies disrupt the workplace must be confronted head-on. This essay critically examines what new design strategies and types of workspace have been put in place.

The Return of the Thin Building

In overarching terms, one of the most significant trends is the return (and inexorable rise) of the 'thin building'. Before the emergence of the personal computer in the 1980s most office buildings were 'simple' or 'thin'. It was the growth of networked technology in buildings with the proliferation of servers, computers and printers connected by miles of cabling through voids into expensive systems furniture that led to a complexity that is evident in most buildings today. The 'intelligent building' was the response to the spread of tethered technology with air-conditioning, raised floors, high-speed lifts and other over-engineered systems designed for a 'just-in-case' world where people became secondary to infrastructure.

But just as office buildings became heavy or 'obese', with 'deep' space to accommodate technology infrastructure, technologies moved in another direction. First we had the 'thin client terminal' – the reincarnation of the 'dumb terminal' of the 1970s where people could share a fixed machine that had no computing power or local storage as documents were moved to remote data centres. But this was short-lived as data migrated to the 'cloud', and fixed devices gave way to mobile devices. New technologies from smart phones and tablets together with wireless technology such as 4G and Wi-Fi meant that all the constraints of the past could be

removed. And as cloud technology advanced, software was also delivered remotely as a service paid for by consumption or use.

A new paradigm has emerged, where people connect to other people, rather than desks and rooms. Buildings no longer need to house technology infrastructure; they are no longer the complex, expensive architectural containers of the past. And so they become thin, devoid of the equipment, paper and paraphernalia of traditional office life and just a place for employees, who increasingly carry their own technology with them in a trend known as BYOD (bring your own device), to come together. It makes sense: as we can work anywhere anytime on our own, these places are increasingly configured as a social landscape.

'Thin' space provides the agility for this to happen, without the constraints and inflexibility of being tethered to a desk, workstation or phone line. 'Thin' space fits well with other manifestations of organisational 'thinness' – flatter hierarchies with swatches of middle management cut away, more energy-efficient buildings with more use of natural light, and a greater emphasis on outsourcing. It also chimes with the rise of the knowledge economy, in which work is no longer rigid, hierarchical, planned, supervised and sequential, as in the industrial economy. Instead innovation is prised out through creating and sharing ideas, through iteration and experiment in an environment that ideally promotes teamwork, trust and conviviality.

The Social Network

To achieve this new type of workspace, to facilitate the communications and connections, the unpredicted interactions and serendipitous encounters upon which knowledge work thrives, designers have adopted a range of architectural strategies. In the 1990s, dizzy with a new freedom from intensely structured, cable-managed offices, many designers turned to historical metaphors, undermining 'modernist' ideals in the workplace by relocating companies away from conventional developer towers and remodelling their offices on the topologies of medieval towns, bridge communities or harbour settlements. One San Francisco bank, newly relocated to a former coffee warehouse, created a gathering space for staff similar to the *parvis* in front of a medieval cathedral.[5]

More recently, however, designers have sought to redefine workspace not simply as un-modern, but as adopting a permeability and unpredictability reminiscent of the Internet itself. In this scenario, social networking online is replicated in architectural space, as all areas of the workplace are geared towards

a constant whirl of collaboration, connection and social interaction. The open-plan office thus becomes as open to possibility and distraction as the web itself, in what the author and management thinker Susan Cain describes as the 'Extrovert Ideal' in workplace design.[6] Cain points out that 'peer pressure' and 'groupthink' in open-plan spaces can actually inhibit creativity and productivity when they are intended to do the opposite:

> We came to value transparency and knock down walls – not only online but also in person. We failed to realise that what makes sense for the asynchronous, relatively anonymous interactions of the Internet might not work as well inside the face-to-face, politically charged, acoustically noisy confines of the open plan office.[7]

Activity-based Working

Nevertheless, a new nomenclature – unplanned, unpredictable unwork – is beginning to describe an approach to the workplace that is shaped by the people that choose to occupy it on a particular day for a specific task, interaction or activity. This is sometimes known as activity-based working, and design schemes have emerged that bring a creative sophistication to this concept that is demonstrably missing in endless examples of low-choice open plan. The Macquarie financial services group, for example, has created exceptional workplaces in London and Sydney, designed by Clive Wilkinson Architects with activity-based working very much in mind. They have challenged the hermetically sealed office building, with its lifts and fire escapes, and instead opened up vast plazas and vertical communities in a vision that creates communication across the boundaries of departments and encourages interaction, mobility and collaboration.

The dramatic Esher-esque red stair of Macquarie's London building demonstrates not just the interconnectedness of shared space but the inadequacy of today's office building – Macquarie had to rip out ten floors of brand new building fabric to create the space it needed. The Sydney office meanwhile shows how the workplace might evolve architecturally as a social network in the future: inside an exoskeleton of steel, like the frames of a giant computer game, a light and open environment features a series of meeting pods that are cantilevered out over the atrium in a distinctive departure from the conventional protocol of providing meeting space. The digital gaming metaphor is inescapable.

Macquarie is not alone as many companies around the world recognise the

Macquarie office interior, One Shelley Street, Sydney. Design by Clive Wilkinson Architects. Photo by Shannon McGrath

Central staircase in Macquarie London headquarters. Design by Clive Wilkinson Architects.
Photo by Riddle Stagg Photographers

importance of interaction through what author Steven Johnson describes as the 'adjacent possible'.[8] The buildings these companies inhabit may be thin buildings, but they are not necessarily 'dumb'. Instead of a backlash against 'intelligent' real estate, a new era is emerging as the Internet begins to connect 'things' together and not just people. Ubiquitous computing or the 'Internet of things' has become the next battleground for the web, with many predicting that more traffic will come from inanimate objects than people in the next few years. And so the rise of the 'connected building' will result in real-time real estate – a vision of physical space where millions of sensors control everything, from lighting and cooling to corrosion and solar gain.

Automation will allow architects and designers new opportunities to create buildings that respond not just to the changing weather outside but also to the people who inhabit them in real time. This will change the experience of being in an office. Location-aware systems and services are set to emerge that will present personalised information to people logging into the workspace on arrival, based on who they are, where they are, what they are doing at a particular time and who they need to collaborate with.

Rather than the 'one-size-fits-all' uniformity of the paper-factory office era, a more variegated, heterogeneous workplace is now emerging. Digital technology may help to make all this happen, but conversely there is added *architectural* pressure to create more stimulating, eclectic physical spaces that provide choice and variety through the working day. Some organisations are doing a better job of meeting this challenge than others. Abe Bonnema's Interpolis insurance company building in Tilburg, The Netherlands, for example, is the much-copied 'poster-boy' of the activity-based hub. This scheme commissioned top Dutch artists to create a diverse series of activity spaces linked by a network of streets and paths – from Marcel Wander's stone houses to Bas van Tol's weaver's hut and Mark Warning's House of Light.

Many of these new spaces look and feel more domestic, neither constrained by rigid technology nor Taylorist-era clock-watching utility. In creating places for con-centration and contemplation, in which people can hide away from the supervisory glare and the hubbub of the crowd, as well as places for intense collaboration, Interp-olis goes some way to addressing a common criticism expressed by many knowledge workers, especially older ones. This is that too much new workspace design neglects the human factors and wellbeing of the individual in favour of the team.[9]

Learning Labs and Co-work Clusters

Some indication of how deep-rooted this dissatisfaction has become can be found in a damning statistic about today's office: an average of 52 per cent of all desks and offices lie empty at any one point in time.[10] At the same time people say they can't find the meeting rooms and project spaces that are being demanded for collaboration. Something has to give, and a new mix is now emerging: fewer allocated desks, more shared environments, with focused spaces for activities ranging from concentration to collaboration and new spaces for learning.

Indeed one of the most striking areas of digital influence on new workspace can be found in the emergence of tech-enabled learning labs that are changing how we generate, capture and share ideas. These are spaces that accelerate the development of new concepts by putting people together in specialised learning environments for innovation, with experts contributing remotely from anywhere in the world. Many of these learning labs have been piloted in academic institutions – Stanford University's D-School and iRoom are good examples – but corporate organisations have begun to follow suit, encouraged by early pioneers such as Price Waterhouse Cooper's multiscreen Zone space for accelerated learning in Philadelphia, designed by Gensler. [11]

Parallel with moves to remodel corporate office space along the lines of the social network, activity hub or learning lab, however, is another consequence of the shift from bricks to bytes – the rise of coworking. This is seeing new work communities develop in which digital-enabled people are working free of the traditional corporation and clustering with others in more radical social space that brings like-minded people together and mentors entrepreneurship. This combination of individual independence and group sharing is what makes coworking so attractive to so many people around the world. And in giving architects a chance to do something more informal and imaginative, cowork spaces also expose the shortcomings of much conventional corporate office design.

Originally coined by Bernie DeKoven in 1999, the coworking term now covers a variety of approaches. In London alone, which is a world centre for coworking, there are several different types of cowork venture, as Pier Paolo Mucelli of eOffice has explained.[12] These range from public spaces (like the British Library's IP centre) and members' clubs (The Hospital Club, Soho House and so on) to independent social enterprises (such as the Hub) and serviced office clubs (Regus lounges and the Office Group Clubrooms). Recently, the corporates have also got in on the coworking act in London, a move exemplified by the Google Campus in

East London and the O2 Workshops in the West End.

The scale of this activity in just one city indicates that coworking as a growing global trend is unlikely to be reversed. Coworkers tend to be young, university-educated and associated with the creative and new media industries; they are not typical of all office workers. But the rise of cowork space suggests that much more needs to be done in architectural design to stem the flow of talent from the corporation, now that digital networks allow to them to escape so easily.

Much of the appeal of coworking clusters lies in convenient locations that relieve the tedium and cost and carbon waste of long commutes. Synchronicity across distance, enabled by mobile devices and high-speed networks, has changed the rules of location. As software and data migrates to the cloud, people will question the need to commute into what are fast becoming 'empty' containers for work. Devoid of all the infrastructure, files, software and processing power, the physical role of the workplace will be challenged as never before. For the office to remain relevant, architectural form will need to evolve. More mixed use, more generous space, more social landscapes offering more imagination, surprise, service and delight, and more dedicated facilities to support the real work that people are there to do, all are required to make that physical trip to work worthwhile. ∎

1 This process is clearly described in A. Forty, *Objects of Desire: Design and Society 1750–1980* (London: Thames and Hudson, 1986).
2 Le Corbusier, *Towards A New Architecture* (New York: Brewer, Warren and Putnam, 1946): 87.
3 See Frances Cairncross, *The Death of Distance: How the Communications Revolution Is Changing Our Lives* (Cambridge, MA: Harvard Business Press, 1997).
4 See www.theguardian.com/artanddesign/2013/sep/06.
5 The project was by Studios Architecture for Babcock and Brown and was written up in *International Interiors 5* by Jeremy Myerson (London: Laurence King, 1995).
6 See Susan Cain, *Quiet: The Power of Introverts in a World That Can't Stop Talking* (New York: Crown, 2012): 79.
7 Cain, *Quiet.*

8 See Steven Johnson, *Where Good Ideas Come From: The Natural History of Innovation* (New York: Riverhead, 2010).
9 See J. Myerson, J. Bichard and A. Erlich, *New Demographics, New Workspace: Office Design for the Changing Workforce* (Farnham: Gower, 2010).
10 Johnson Controls Presentation at WorkTech Melbourne, 29 February 2012. Unwork research. Philip Ross and Mark Dixon, *VWork Report* (Unwired Ventures Ltd, 2012).
11 See Jeremy Myerson and Philip Ross, *The 21st Century Office* (London: Lawrence King, 2003).
12 Presentation by Pier Paolo Mucelli, 'Coworking: The London Market', Worktech London conference, British Library, November 2012.

A New Product
Harun Farocki

How are changes in society reflected in corporate structures? Over the period
of one year Harun Farocki joined the meetings of the Quickborner Team (QT), a
business consultancy in Hamburg, as they developed a new consultancy product.
QT specialises in organisational building planning and property management
(meaning the design of workspaces, offices and social zones) with the aim of
optimising business processes and organisational structures. Farocki's newest film
portrays the brainstorming sessions about new concepts for mobile workstations
which would grant employees a high degree of autonomy – and leave experts
grappling for words. The product concept is bold, but intellectually flimsy, and
best serves as a reflection of existing world order. Once again, coloured markers
and eye-catching graphics are used to disguise heartless capitalism. The cutesy
branding of neoliberal market economics is grotesque...and fascinating.

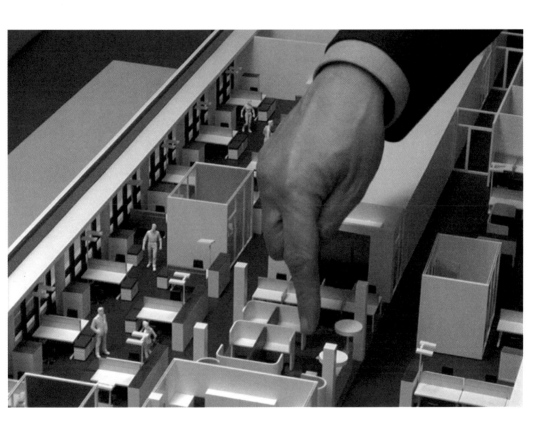

Defrag Life
Alon Meron

8–8–8, 8 hours for each – work, rest and leisure – the right to work and have time to call your own. The right to have a life. It used to be a slogan to march to, fists in the air. Now we yearn for it, absent-minded. Strangely, the values it stands for are in as short supply today as they were 203 years ago.

Our days are being fragmented beyond the tripartite segmentation of 8–8–8. Our time is made of ever-smaller units, and what used to be a rhythmic sequence of work and rest spanning a week now threatens to become a constant drone, punctuated by the occasional significant event. Work bleeds into life and leisure is made manifest in our workplaces.

The exhibition design for *Time & Motion* uses square frames, modules to represent the sense of fragmentation in a system, of things being diced to smaller units and recomposed. The timber structures remind us that work is some kind of scaffolding for our lives. We are 'Homo Laborious' and we have neither life nor moral standing without work.

These structures run through the exhibition space, providing order to the materials within them before collapsing into increasingly complex fragmentations as we seek to discover a new system of categorisation of work–life balance.

WHAT

WILL

WORK

BE

TOMOR-

ROW?

Work and Wellbeing in Digital Public Space

Ben Dalton and John Fass

Work is changing rapidly as the dimension and scale of digital instruments continue to rise. A vast space of memory, processing power and connectedness changes the physical workspace, working practices and our relationship to employment and reward. We might think of 'digital space' as an additional or parallel dimension to the physical world. But as the digital dimension opens up scope for massive-scale information processing and storage whenever and wherever it is required, digital space and physical space have become intertwined. Previous technological leaps in worker roles have often been about changes in constraints of space and time – the coordination of clocks, connectivity of ships or railways, the efficiency of mills, office towers and even the physical size of silicon chips. So how is the nature of work changing with the ever-increasing resources and features of digital space?

Digitally enabled processes and tools for work show a trend towards the breaking down of tasks into small, and therefore manageable, component parts. Roles traditionally completed by a single person can be shared in this way across a team. In this essay we propose that there is a quality to digital public space conducive to this fragmentation and that it has an implication for how we define work, how it is carried out and who does it. We describe how traditional worker roles are fragmenting through the influence of digital processes, and as fragmentation continues into smaller and smaller parts, how we are starting to see the possibility for cohesive forms to re-emerge as the resolution (number and density) of the fragments becomes great enough for new meanings of work to appear.

Digital space is changing different aspects of work at different paces, destabilising the balance between aspects of production, management and wellbeing. Fragmentation in business practice is not new and has historically been beneficial to those industries willing to embrace it through models such as supply chain integration, outsourcing of roles and tasks, and decentralisation. Examples

of successes in free and open-source projects have demonstrated that fragmented management models can match or outpace traditional centralisation.

In this essay we describe trends in the further fragmentation of production and management, largely found in a new breed of digital organisations, where entire categories of work have been dissolved into algorithmic testing and hidden user labour. Individual worker roles have been broken down into complex systems of activity and use, bound together with digital resources and computation. Traditional aspects of wellbeing appear to be slow to keep pace with these changes.

Digital Fragmentation

Digital technology is characterised by the storage, transformation and transfer of information in the form of 'bits', usually computed as 1s and 0s. Claude Shannon[1] outlined the theory that describes how signals, words and data can be held in this binary format and probabilistically communicated, while taking account of loss and noise on the channel. This loss-less processing of information sets out the principles of 'general computation'. A computer that can handle any digital information simply as a series of bits does not need to be built with a specific task in mind and does not need to be re-engineered for each individual task. This disconnection between infrastructure and use means that the science of computation can advance extremely rapidly, and unexpected uses for this technology can evolve. Work roles that were often defined by proximity to, or skilled use of, a tool or resource can be divided up into component parts.

Large-scale programming projects – inherent to digital space – are often characterised by a process of fragmentation. In free and open-source projects in particular, roles that would have traditionally been completed by one or two people are often broken down into much smaller parts and carried out by a distributed network of thousands.[2] Searchable storage, annotation, interface design and computational connectedness are used to compensate for the disorder of the fragments, allowing large numbers of people to contribute, but many at a low level of engagement in terms of skills and participation.

This process also makes system rules (algorithms) more important since many separate people carry out similar tasks in widely varying contexts. The process of solving a significant challenge then shifts from the act of a single worker completing a task to a swarm of activity gradually pushing forward on a problem following a set of cascading rules and priorities determined by the group. Splitting a task into multiple parts requires detailed (often automated) planning,

The dependability of a fragmented system of work relies on a redundancy of participants in the process

but can deliver efficiency (productivity, economies of scale, levels of completion). Dividing the tasks up further becomes unmanageable as tracking, inter-communication and documentation workloads increase with the number of parts in the system.[3] The dependability of a fragmented system of work relies on a redundancy of participants in the process. Fragmentation needs to continue far enough so that the parts seem to represent a new whole. A traditional job can be substituted by a swarm of activity, which acts as a coherent form at a distance if the resolution is high enough.[4]

We can start to see examples of high-resolution fragmentation in successful open systems. The tone of voice within the articles of Wikipedia for example is relatively consistent despite the community size. The encyclopaedia is sustained by a deep digital space of social interaction, participation tools and historical edits stretching out 'behind' each current page of the website. Wikipedia also features a complex set of instruments to bring this quality into being; from how screen interactions are organised to the consistent information architecture across articles, to editing procedures and participation guidelines. The key aspect of this texture (or resolution) of digital activity is that it was not imposed or predetermined but has evolved over the lifetime of the project (and continues to do so) in response to participants' views, actions and contributions. It is a consensual system.

The Public in Digital Space

How might industries traditionally dominated by paid work draw on wider audiences of participation that open communities regularly benefit from and that appear a necessary component to achieve high-resolution fragmentation?

Free and open-source projects combine contributions from paid and unpaid workers by building on a context of equal, 'public' ownership. Other industries that are traditionally based on private, corporate ownership of creations and products are currently faced with a difficult transition when trying to draw on fragmented worker contributions that include their 'users' or 'consumers'. The problems they face relate to how they are perceived by their customers, how ownership is centrally organised and how they understand the nature of participation and control.

In many instances the corporations and government departments driving digital developments are organisationally indistinguishable from their twentieth-century counterparts. They depend on management hierarchies, careful deployment of resources, attraction of outside investment and shepherding of a globally listed share price.

One model is to hide the nature of the work while using the worker to perform 'human computation'.[5] The financial value of creativity, filtering and documentation in environments like Facebook is hidden from its workers ('users'). They are rewarded instead in kind with some free storage, a highly structured social instrument and software stability. Human computation can be a productive way of solving socially oriented problems since the number of opinions needed to classify a category convincingly varies between tasks; often fewer responses (or computations) are needed to reach full resolution.

The financial value of creativity, filtering and documentation is hidden from its workers

Researcher Luis Von Ahn is best known for demonstrating alternative forms of reward for human computation. These include 'fun' as a reward in the image tagging ESP Game,[7] 'fulfilment' in the language-learning transcription site Duolingo and 'function' in the case of ReCaptcha log-in tests that verify a user as human while also digitising scanned documents.[8] Examples like the map editing interface on Google Maps borrow directly from the successes of the Open Street Map project. But the value of the work done in updating a map is downplayed, with the contributions to Google's map being locked into its license agreement, which prevents contributors from adapting its maps for anything but personal use.

The repercussions of lost ownership of the contributions made in all of these systems has yet to be fully examined. Indeed much user participation currently seems to succeed by hiding traditional transfers of ownership deep within the click-through small print of the online terms and conditions. The terms of participation are then heavily weighted on the side of the corporations involved.

Companies are also finding that they can go further without asking their customers to be workers at all. For example, Google's location services for Android phones harvest data from people using the devices. Its maps are faster to

pinpoint a location than standard GPS because they draw on a database of known Wi-Fi hotspots. However, this database is updated unknowingly by the users of the system when they agree to Google's terms of service. In summary, access to and supply of work in digital public space is dependent on a series of infrastructural disruptions and features a complex arrangement of technical and social elements whose effects we are only beginning to observe.

Fragmenting Worker Wellbeing

Worker wellbeing is founded on traditions that have changed little in comparison with the fragmentation of production and management. The engineering production paradigm favours efficiency, throughput and clearly definable outcomes. Despite sharply reducing the cost of connectivity, digital technology can also enable disconnection. Personal user interfaces and algorithmic time management can act to reduce human contact. Policies that lack humanity can be enforced more easily if there are no humans to directly witness the impact.

Systems of support for wellbeing, safety and social security have adjusted weakly to fragmented working practices and tend to prioritise aspects of production and resource allocation. Free and open-source projects have not had to consider much of the traditional architecture of social security because there is often no payment for work. While mechanisms have developed in some digital spaces to manage abuse and marginal voices, other concepts such as minimum wage, maximum working hours or sickness support are largely sidestepped because these are traditionally regulated through pay and union representation, and most contributors to such projects are giving their time for free.

Even in many traditional industries we can see the effects of digital space on wellbeing. Email has allowed employers and managers to shift the risk of time management and accountability to their employees, and shift tasks into unpaid time. Rapid automation has left cohesive working communities suddenly without skills or systems of support. Cheap communication networking allows outsourcing of the service industry to areas of the world with this month's cheapest wages or lowest worker rights, in a race to the bottom. There has been a corresponding attempt to imbue digital systems with human-like characteristics, often related to tone of voice, speed of response and the tropes of physical world affordances such as transparency, lighting effects and angles of view.

While it is true that new communities have emerged in response to distributed working practices (the open-source movement is a good example) around

a shared set of principles, they are often missing some of the essential signifiers of human-scale communities such as limited numbers, face-to-face meetings and informal communications. Shared values are often codified in frequently asked questions and terms and conditions documents rather than negotiated in shifting social contexts. The way digital work interactions are described often conceals their fundamental differences to real-world social dynamics and their essentially metaphorical relationship to real-world interactions.

Digital public space is largely denatured of the rights that people have treasured about work for five generations

We can see the effects of the unequal pace of fragmentation for production in comparison to worker wellbeing in instances where these principles have been applied to paid work. Amazon's Mechanical Turk allows people to sign up to a listing interface and select small tasks to complete for micro-remuneration. A job on Mechanical Turk might involve looking at an image and clicking to indicate if it is pornographic or not. Each task requires only moments of attention and effort, and pays only a few cents or tens of cents. The start-up Task Rabbit goes a step further and requires potential workers or 'rabbits' to bid on proposed neighbourhood tasks listed on the site. The number of participants means that there are likely to be enough workers 'on-call' whenever a task is offered.

What we see is not outsourcing of a company division to another country, but rather outsourcing to each individual worker the responsibility for work space, time management and employment risk. This is exemplified by oDesk, e-lance and Guru, just three among many sites (much like TaskRabbit) that offer opportunities for freelance workers to earn professional income. By 2013, oDesk alone claimed to have brokered $1 billion in online work. The revolution these companies represent is infrastructural and dematerialising. There is no need for employers to consider actual desks, lighting, insurance, healthcare, heating, stationery or legal advice. They are either virtualised or irrelevant to the oDesk workplace.

Employers post job specifications with a budget attached and freelancers all over the world undercut each other to win the work. oDesk provides a measure of security in the form of a legally binding contract. Union representation, income protection, a stake in company decision-making or pension provision are entirely

sidestepped. The hard-won rights of people in the workplace at every level have been rendered obsolete. Digital public space in this context is largely denatured of the rights that people have treasured about work for five generations. The online freelance environment does of course still demand the responsibilities of timely supply of work, completed to budget, featuring a high standard of finish.

The mechanisms of collective wellbeing seem slower to expand into digital space than the practices of work itself. Historically, we have seen new forms of collective bargaining evolve as technological invention gives rise to new forms of work. Can we expect that the same affordances of digital space that have made production and management more efficient through fragmentation may also enable new forms of insurance and protection for workers?

Might we imagine, for example, a geographically distributed team of workers, having developed an efficient working practice through collaborative online gaming, who 'job-share' a single well-paid job that requires someone to be on-call at unexpected hours? Or could it be possible for a group of zero-hour contract workers to collaborate on reallocating their unreliable shifts between the group depending on their own childcare responsibilities? The same methods for splitting work into smaller, more fragmented tasks could act to more evenly distribute the kinds of work that have historically been divided along gender and class lines.

Fragmented worker wellbeing may also draw on the support and recognition systems of unpaid work. As worker roles become split into small low-paid tasks or unpaid user labour, communities of support, patterns of lower consumption and non-financial trade may become more important. These forms have substantial precedent in work such as care or craft that is historically unpaid or undervalued in terms of remuneration.

In summary, existing digital affordances have important implications for the rights and responsibilities of the future workplace. We recognise that a pre-existing set of social and technical instruments for collaboration, collective bargaining and wellbeing can be adapted and configured to offset some of the negative effects of these affordances. Global networking enabled the outsourcing of business activity far beyond spatial constraints and national borders. Rapid-access storage allowed for documentation of tacit knowledge and progress tracking, enabling tasks to be divided into even smaller parts still. Search and algorithmic ranking has further helped management to control and coordinate the fragmentation of task completion. User labour has allowed businesses to draw on similar growing scales of contribution without having to acknowledge the people solving the tasks as workers.

Through all of this, mechanisms of wellbeing have struggled to keep pace. A rhetoric of flexibility and freedom-to-participate hides the production efficiency needs of business practice. Digital tools of mass customisation have further helped to foster an often shallow sense of personalisation and individual importance – change your profile picture and live in the Google filter bubble.

However, outside of the co-ownership models in free and open-source projects, traditional concepts of worker rights, representation and negotiation have largely failed to keep up with digital tools. The eight-hour working day was achieved on the back of collective representation and negotiation of workers' rights built on professional and industry-based structures. What might digital post-fragmentation unions be like? Could there be task-level unionisation, micro-whistleblowing and radically networked worker councils? We call for new integrative forms to emerge from the fragmented nature of online 'employment' and new digital protocols for wellbeing in a person-centred digital workspace. ∎

1 Shannon's work in the late 1940s turned out to have profound implications not only for computer science, cryptography and communications research but also in psychology and sociology and across the humanities. See C.E. Shannon, 'A Mathematical Theory of Communication', *Bell System Technical Journal* (July/October 1948).

2 For example, rather than one programmer trying their software on hundreds of different purchased test computers, they might use a system to elicit feedback from thousands of volunteer users each already using a unique computer setup, and hundreds of fellow programmers interested enough to rank or tidy some of the resulting information.

3 This is the argument of the 'mythical man-month', that adding more people to a project often increases the workload because of the burden of communicating changes in the larger network.

4 For example, a well-fragmented business support system may contact a customer via web chat, and then email, and then phone call with the consistency of a single personal conversation despite being serviced by a series of temporary support staff and additional customer tracking systems.

5 Cognitive work which humans are better at than computers.

6 'Players' in pairs try to guess words to describe images, which also provides effective labels for those images – now licensed as Google Image Labeler.

7 'Learners' practice a foreign language by translating short texts, and simultaneously help to translate the web in to their home language.

8 'Users' are shown two words they must type to submit a form, thus deterring spam and also helping to digitise poorly scanned words from books.

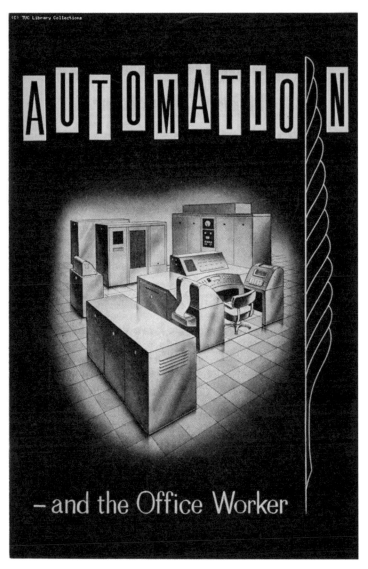

Automation and the office worker, 1961. Courtesy of TUC Library Collections, London Metropolitan University

Redefining Working Life
The Creative Exchange

The Creative Exchange (CX) project, which is partnering with FACT Liverpool in presenting the *Time & Motion* exhibition and public programme, has a remit to explore the innovation potential of 'digital public space'. It is one of four national knowledge exchange hubs funded by the Arts and Humanities Research Council (AHRC) as part of a large-scale initiative to expand the creative economy in the UK.

The CX hub comprises research teams from the Royal College of Art's Helen Hamlyn Centre for Design and School of Communication, Lancaster University's Imagination Centre and Newcastle University's Culture Lab. Professor Rachel Cooper of Lancaster University is the Principal Investigator on the project.

The three participating universities are developing new products, services, interfaces and experiences for national field trials. MediaCityUK in the north west, home of the BBC, is the primary geographic focus for the project. The CX Hub is supporting the north west regional strategy for growth in digital and creative media industries. A cohort of more than 20 doctoral researchers is working on the project in the three participating institutions. They are based in a dynamic series of CX clusters, developing projects with academics and industry partners and contributing to new knowledge exchange practices.

The Royal College of Art has made a distinctive contribution to the CX Hub by initiating a strand of collaborative work exploring how the digital public space might support a rethink of the temporal, physical and social boundaries of working life. Three projects are showcased in a custom-designed CX co-working space at the entrance to the exhibition: *Hybrid Lives, Rhythmanalysis* and *Where Do You Go To?*

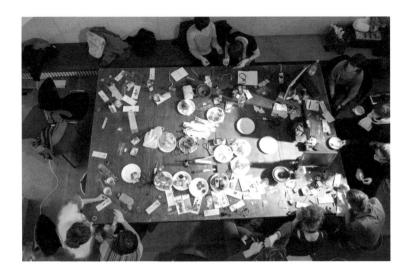

Hybrid Lives

Hybrid Lives is a collaborative design and research project resulting in a free, public co-working space at FACT in Liverpool. The project explores the way working life is changing for many people. The rapid pace of change in digital technology means completely new types of work are being invented, such as *social media manager* or *information architect*. This kind of work demands new skills, new forms of collaboration and a new way of separating work and life. In an always-on culture of Internet-connected objects, smartphones and 24-hour email traffic, there is a need to acknowledge how working practices are changing, along with workplaces and the office environment.

Flexible working practices mean the boundaries between home and work life have become blurred. As more work is dependent on digital technologies, so the workplace is transforming into a hybrid, mixing the physical with the digital, the domestic with the commercial, and public with private. The boundary between what is work and what is leisure can be hard to detect with numerous examples of digital corporations exploiting unpaid online activity for corporate gain. Digital technology enables different and more mediated ways of communication, sharing and collaboration to take place, but the pace of change often leaves little time to assess the

implications for people.

People interact with, and thereby transform, their home and work environments by generating personal data, inhabiting new online personalities and creating new uses for technology. This in turn creates new types of social grouping, cultural practices and capabilities. While many of these phenomena are not new (modern workplaces have been adapting to new technologies at least since the industrial revolution), the digitally mediated knowledge economy appears to have some unique implications for workplace behaviours and some distinct opportunities for designed environments and objects.

Hybrid Lives attempts to illustrate some of these opportunities, reveal the social relations at work and delight the visitor with a series of creative experiments. Interactive tables measure and display bandwidth usage; video works blend live images of current and historical working life; a textured visual treatment evokes the synthesised nature of digital working. The physical space, configured to accommodate collaborative working, hosts the visitors who come to work, play or merely observe. The installation itself is also seen as an experimental apparatus, a work in progress through which workplace behaviour is revealed and displayed. ▌

CX project partners:
Peter Bosson - Bosson Group
Luke Connoley - Unwork
Ben Koslowski - RCA
John Fass - RCA
Karen Ingham - Swansea Metropolitan University

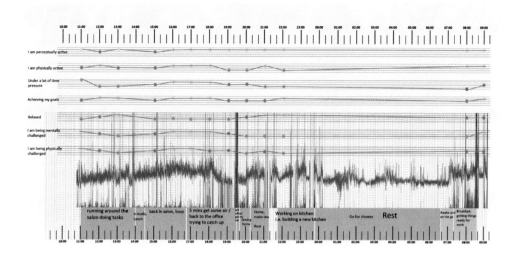

Rhythmanalysis

Rhythmanalysis takes inspiration from the Henri Lefebvre book of the same title [1] in which he draws attention to urban spaces having embedded rhythms, which in turn have effects on the rhythms of people's 'everyday life'. Taking Lefebvre's argument into a twenty-first-century context, we argue that not only physical but also 'digital public space' has begun to shape new rhythms of everyday life. Yet, despite the evident impact of this, we have no tools to 'map' or evaluate the transformative potential of the digital public space on working life and little to no critical evaluation strategies to manage this new element in our everyday lives.

For many workers and employees in the UK (as well as many other countries), instantaneous digital communication technology created a sense that we are available anytime and anywhere. A recent study has shown that 83 per cent of managers are regularly contacted by their employers out of working hours and more than 75 per cent of employees work regularly beyond their contracted hours. [2] This trend is expected to rise in the context of an ever-more efficient integration of 'digital public space' with our working and private lives and there are now concerns with regard to the long-term effects of not having a sustainable model for a 'work-life balance'.

The *Rhythmanalysis* team focused on two distinct working environments in Liverpool – Sony Games testers and Minsky's hairdressers – and used a combina-

tion of wearable technology from Cambridge-based biotechnology company CamNtech to measure heart-rate and motion and to deliver scheduled questions that gather information on the qualitative experience of life and work and the workers' relationship to both. This data was then combined with a simple written diary of their physical activities throughout the day. The tracking/sensing technology starts to show us how such data could assist as a self-reflective tool to improve daily (work) life.

Achieving the right work-life balance affects us all. There is no escaping the need to work: though financial gain, a sense of duty and adding value to life plays a key role in participants' experience of work, so too does the need to feel purposeful while doing it. Though mindful throughout of the relative sensitivity of displaying even anonymised participant data, the participants and their employers were both generous and engaged in the design process – aware that at the heart of the research was a fundamental question that affects each and every one of us in every generation.

Participants became aware, in ways that surprised them, of the value of tracking oneself across physical and mental space and even began to look at adjusting and modifying their behaviour as a consequence. It is precisely this heightened level of awareness through emerging digital/physical interfaces that could, in the end, have long-lasting benefits as to how we perceive ourselves in relation to the world in which we work. ▮

CX project partners:
Alistair Eilbeck - Amaze
Richard Koeck - Liverpool University
Roger McKinley - FACT
Veronica Ranner - RCA

Where Do You Go To?

Sharing images of desks and workspaces is a non-intrusive way of staying connected in teams including freelancers, commuters and distant collaborators. In 1995 Frances Cairncross's *The Death of Distance*[3] declared a compelling vision, that over time the communications revolution would release us from geographic locales. Digital space has redefined working life, untethering workers from their desks and workplaces. It has enabled the opportunity to work anywhere, anytime. Yet digital space simultaneously lacks geographic substance. It is both nowhere and everywhere.

Where *Do You Go To?* responds to a growing need for design solutions that reduce 'psychological distance' and foster a sense of 'connectedness' in distributed working. It explores how digital visualisations of workspaces can create a sense of being 'local' in digital space and enrich human experience independent of geography. Partnered with BBC MediaCityUK for field trials, this project combines design prototyping in an experimental collaboration with staff and associated creative freelance networks.

Connectedness and context awareness are key ingredients of successful workplaces. Dynamics of suitable interruption, serendipitous collaboration, tangential inspiration or group dynamics are, for example, all dependent on a shared knowledge of working patterns, context and 'state of mind' for those who work

together. Within shared workspaces, knowledge of context is often tacit and channels of connectedness remain diverse, ambient and difficult to categorise. Digital communication systems often lack ongoing channels of ambient connectedness and context.

Our project has designed an app that takes photos and displays the workspace image each team member has shared, and has tested this prototype with a group of collaborators at the BBC. A workshop beforehand helped to inform the design and follow-up interviews have enabled us to reflect on the experiences.

The BBC MediaCityUK in Salford offers a unique testbed for exploring these themes. Designed and built over the last seven years, it represents an architectural office interior and organisational design process in its early stages of adoption and adjustment. The recent geographic relocation also creates a distinct environment for studying remote collaboration as the existing working ties of the BBC are now spread over several sites in the UK, and teams are often composed of members who have relocated, are commuting regularly, or have recently joined newly sited groups.

Our approach has been to experiment with the feeling of 'being in touch' in the context of ongoing projects involving both BBC staff and freelance networks. The collaboration provides an opportunity to highlight the existing networks and value the BBC has fostered, and to explore tools for further strengthening these networks through communication and tools for visualisation. It is specifically focused on understanding how BBC staff and freelance collaborators might use 'digital sharing of physical workspaces' to support and enrich their creative networks in new ways. The value of a sense of 'connectedness' arguably lies in the facilitation of a shared collaborative culture as the linchpin of future economic advantage. ∎

CX project partners:
Ben Dalton - RCA
Bridget Hardy - Integrans Consulting, Ltd
Claire McAndrew - The Bartlett, UCL

1 H. Lefebvre, *Rhythmanalysis: Space, Time and Everyday Life* (London: Continuum, 1992; original published in French).
2 D. Clutterbuck, *Managing Work–Life-Balance* (London: CIPD, 2003).
3 F. Cairncross, *The Death of Distance: How the Communications Revolution Is Changing Our Lives* (Boston: Harvard Business School Press, 1995).

Editor Biographies

Emily Gee
is a curator at FACT,
Liverpool. She studied Fine
Art at Liverpool School of
Art and Design and gained
an MA Critical Writing and
Curatorial Practice from
Chelsea College of Art and
Design during which time
she curated events and
exhibitions at Tate Britain
and Bargehouse, OXO
Tower. After graduating
Emily became experienced
in negotiating the
contemporary world of work
through a series of zero
hours contracts. In her spare
time Emily is editor of a zine
about twentieth-century
architecture and design and
her research interests lie
in urban space, power and
ordering systems.

Jeremy Myerson
is an author, academic
and activist in design and
innovation. He is Director
and Chair of the Helen
Hamlyn Centre for Design
at the Royal College of
Art, London. Key themes
of his research include
changesli workplace design
and design for an ageing
society, and he currently
holds a co-investigator
role on the AHRC-funded
Creative Exchange hub. A
former journalist and editor
for such titles as *Design*,
Creative Review and *World
Architecture*, he founded
Design Week magazine in
1986. His many books on
workplace design include
The *21st Century Office*,
The Creative Office and
*New Demographics, New
Workspace*. Jeremy was
born and brought up in
Liverpool and holds arts
degrees from the University
of Hull and the Royal
College of Art. He sits on
the advisory boards of
design schools in Korea
and Hong Kong, and in 2012
he was named by *Wired*
magazine as one of Britain's
100 most influential people
in digital technology.

Contributor Biographies

Ben Dalton
is a computational design and experimental media researcher, currently on research leave from Leeds Metropolitan University to work with the AHRC Creative Exchange hub as a PhD candidate at the Royal College of Art. He has recently been guest Professor at the Bergen National Academy of Art and Design, co-investigator on several EPSRC projects on interactive urban spaces, and co-director of the VERDIKT-funded Data Is Political symposium. He has a background in ubiquitous computing and mobile sensor design from MIT Media Lab and has conducted research in the Århus Electron-Molecular Interaction group, Leeds Spintronics and Magnetic Nanostructures lab, as well as Jim Henson's Creature Shop. Ben has recently presented work at the EPSRC Digital Economy Communities and Culture Network and Mediating Heritage workshop, AHRC Digital Transformations moot, Include Asia 2013 and WWW2013 International World Wide Web conferences, and at the FutureEverything and Today's Art festivals.

John Fass
is a designer, researcher and lecturer. He is currently a PhD candidate at the Royal College of Art as part of the Creative Exchange hub and a visiting lecturer on the RCA programme, Information Experience Design. He has a background as a digital designer and has worked professionally in information architecture, interaction design and user interface design, working for many different clients including Arup, Sony Music, Exxon, National Maritime Museum and Adaptive Path. He is interested in digital ethnography, how technology influences people and society, and how computational storytelling might draw meaning from digital data records. Research activity includes publishing internationally in the context of HCI, journalism and interface design; practice-based activity in the design

of distributed screen experiences; and carrying out field research into digital narratives. John holds a BA Hons in Photography, Film, Video and Animation and an MRes in Information Environments.

Bronać Ferran

is a curator and writer based in London. She has pioneered the development of interdisciplinary practices across and between arts, science and technology boundaries through previous work at Arts Council England and currently for the RCA CX Hub, the Ruskin Gallery at Cambridge School of Art (where she is a guest curator), the University of Plymouth where she works closely with Professor Deborah Robinson on projects relating to genomics and ecology, and through her agency, Boundaryobject.org, which works nationally and internationally in the spaces between disciplines. She has been on the juries of Transmediale and Prix Ars

Electronica Hybrid Arts and writes regularly for Neural, as well as other media-related journals. She has a MA from Trinity College Dublin in Arts (Letters) and was born in Belfast.

Richard Koeck

is Professor and Chair in Architecture and the Visual Arts in the School of Architecture where he leads the first year of the Masters Programme (RIBA). He is director of the Centre of Architecture and the Visual Arts (CAVA), director of postgraduate research in the School of the Arts and founding director of CineTecture Ltd. Richard is trained and practised in architecture and filmmaking in Germany, the United States and the United Kingdom. Over the last decade, his films and installations have been exhibited at influential international architectural exhibitions, such as the Architectural Biennale in Venice, but also at film festivals and museums, such as in Rome, Florence,

New York, Chicago and Liverpool. He is co-editor of several books, including *The City and the Moving Image* (2010), and author of numerous articles and book chapters. His latest monograph is called *Cine Scapes: Cinematic Spaces in Architecture and Cities* (Routledge, 2012).

Philip Ross

is an author, speaker and consultant on the new world of work and founder and CEO of UnWork.com. He focuses on the impact that emerging technology will have on the way people work and the physical workplace of the future. Philip has written a number of books including *The Creative Office, The 21st Century Office and Space to Work* (all co-authored with Jeremy Myerson) and has published a number of research papers and reports including 'The Cordless Office' (1994), 'Bluetooth' (1997), 'Office Wars' (2005), 'Creative Places' (2009) and 'Agility@Work'

(2011). He has contributed to a number of other books including *The Corporate Fool* and *The Responsible Workplace*. Philip founded the WorkTech global conference series in 2003 and sits on a number of boards and committees, including the Cabinet Office Property Advisory Panel.

Mike Stubbs

is the Director of FACT, Foundation for Art and Creative Technology, the UK's leading organisation for the commissioning and presentation of film, video and new media art forms. Stubbs was jointly appointed by Liverpool John Moores University in 2007, where he is Professor of Art, Media and Curating. Previously he was Head of Program for ACMI, Melbourne. Encompassing a broad range of arts and media practice, his arts management, curating and advocacy has been internationally acknowledged. Stubbs has commissioned and produced over 350 exhibition programmes

including White Noise for ACMI, the Nam June Paik retrospective with Tate Liverpool, and Pipilotti Rist at FACT and founded the ROOT (Running Out of Time) and AND (Abandon Normal Devices) festivals. Stubbs is an award-winning moving image artist whose work has won more than a dozen major international awards. He is fellow of the RSA and was awarded a Fleck Fellowship, Banff in 2002.

Georgina Voss

is an interdisciplinary researcher and writer whose work examines intersections of technology, politics and culture. She is a contributing researcher to the Creative Exchange at the Royal College of Art, Visiting Fellow at SPRU, University of Sussex, and Honorary Research Associate at the Science and Technology Studies Department, UCL. Georgina holds an MBiochem in Biochemistry with History of Science from Oxford University and

MSc and PhD in Science and Technology Policy from SPRU. Drawing on STS, innovation studies and cultural studies, Georgina's work focuses on: technology practices, politics and ethics; user-led design and grassroots innovation; and gender and sexuality. She has been published in *The Guardian*, *Wired*, various journals and books, and she has produced essays and policy reports for bodies including NESTA, BIS and the EU. Her current book project, *Stigma* and the *Shaping of the Pornography Industry*, is due to be published by Routledge in 2014.

Artist Biographies

Gregory Barsamian became interested in the dream analyses of twentieth-century psychiatrist Carl Jung as a student of philosophy. He later became interested in the zoetrope, a nineteenth-century optical device that uses images and rotation to create the impression of animation. Barsamian is able to explore theories of dreams and the unconscious by replacing images with sculpture, creating a dream world, one that melds art, science and technology into a shadowy realm.

Barsamian's most recent commission was for the world's largest private collection at David Walsh's Museum of Old & New Art, Tasmania. He has works in collections worldwide, including ICC (Inter Communication Centre) in Japan and Kinetica Museum. Gregory Barsamian is represented by Kinetica Museum.

Revital Cohen Tuur Van Balen run a London-based experimental practice that produces objects, photographs, performances and videos exploring the tensions between biology and technology. Through re-appropriating processes, systems and organisms they create work that questions the context in which these materials and processes operate.

Cohen and Van Balen exhibit and lecture internationally. Recent exhibitions and talks took place at the MoMa, Tate Britain, National Museum of China, Museum of Contemporary Art Tokyo, Yerba Buena Center for the Arts, CENART Mexico and Boijmans Van Beuningen, amongst others.

They are the recipients of several awards and commissions, including the Science Museum's Emerging Artist Commission, Wellcome Trust Arts Awards, an award of distinction at Prix Ars Electronica and First Prize at VIDA 14.0 Art & Artificial Life Competition.

Jeff Crouse
creates software, web applications and installations that invite people to enjoy the absurdity of technology. His projects involve robots, generative software, crowdsourcing, computer vision techniques and popular web platforms. He rails against the preciousness of technology using parody and satire. His work has been shown at the Sundance Film Festival, LABoral Art Center, the Performa Biennial, Eyebeam Art & Technology Center, StoryCollider, the Obie Awards and featured in the Berkeley Art Museum Net Art. He has received grants from Rhizome and Turbulence, and has completed residencies at Eyebeam and Minneapolis Art on Wheels. He has pieces on permanent display in Dayton, Ohio, and Beirut, Lebanon. He is currently a freelance programmer with studios such as Hush, Flightphase and the Rockwell Group LAB, and teaches in the Parsons Design and Technology MFA programme. jeffcrouse.info

Electroboutique
(Aristarkh Chernyshev and Alexei Shulgin) is a unique creative electronics production company, an art-supporting fund and an artist collective. Our products are developed in modern technological forms, user-friendly electronic devices and computer programs, which at the same time are the artworks. Our products exist beyond national and cultural borders; they could be seen in trendy interiors, as well as at contemporary art exhibitions and art fairs. Our amazing products are born where cool aesthetics meets information technologies, modern design, pop-art and real-time data processing. Our techniques amalgamate open source and proprietary solutions with the best media art inventions of past decades. We make up-to-date market-friendly art, following recent critical discourses. www.electroboutique.com

Blake Fall-Conroy
is an artist and self-taught mechanical engineer. Born in Baltimore, Maryland, he moved to Ithaca, New York in 2002 where he later received a BFA in sculpture from Cornell University. As a mechanical engineer he works for International Climbing Machines, where he designs and fabricates remote-controlled robots that climb vertical surfaces. As an artist, Blake's projects are conceptually motivated, commenting on a wide range of issues from consumerism and the American spectacle to surveillance and technology. His projects often incorporate mechanical and electronic components as well as objects or motifs found within the routine of everyday life.

Harun Farocki

was born in Nový Jicin (Neutitschein) in then-German-annexed Czechoslovakia but has lived and worked in Berlin for over forty years. Farocki studied at the German Film and Television Academy Berlin (West) between 1966 and 1968 where he began his prolific filmmaking career. In 1974 he became author and editor of the journal Filmkritik in Munich and between 1993 and 1999 was visiting professor at the University of California, Berkeley. Since 1966 Farocki has created over 100 productions for television and cinema and his work spans the genres of children's television, documentary films, film essays and narrative films. In 2004 Farocki became a guest professor at the Academy of Fine Arts Vienna and was appointed full professor from 2006–11.

Ellie Harrison

was born in London in 1979 and now lives and works in Glasgow. She describes her practice as emerging from an ongoing attempt to strike a balance between the roles of 'artist', 'activist' and 'administrator'. She uses skills and strategies drawn from each of these perspectives to create fun and engaging work, both in and out of art world contexts, thereby aiming to expose and challenge the systems which control and rule over our lives.

As well as making politically playful works for gallery contexts and beyond, she is also the founder and coordinator of the national Bring Back British Rail campaign – which strives to popularise the idea of re-nationalising our public transport system – and is the agent for the Artists' Bond, a long-term speculative funding scheme for artists.

In 2011 she was short-listed for the Converse/ Dazed Emerging Artists Award with the Whitechapel Gallery in London and in April 2013 she became Lecturer in Contemporary Art Practices at Duncan of Jordanstone College of Art & Design.

Adrian McEwen

is a creative technologist and entrepreneur based in Liverpool. He has been connecting devices to the Internet since 1995 – first cash registers, then mobile phones and now bubble machines and lamps. He founded MCQN Ltd, an Internet of Things product agency and is co-founder of DoES Liverpool, a hybrid co-working/makerspace that incubates Internet of Things start-ups in the north west of England. He is also Chief Technical Officer of Good Night Lamp, a family of Internet-connected lamps. He was one of the first employees at STNC Ltd, which built the first web browser for mobile phones and was acquired by Microsoft in 1999. Adrian concentrates on how the

Internet of Things intersects with people's lives and how heterogeneous networks of devices should work together. He lectures and speaks on these issues internationally.

You can find him on the Internet at www.mcqn.net, or follow him on Twitter as @amcewen.

Sam Meech

is an artist and videosmith, based in the north west of England, whose work often attempts to link digital and analogue systems. Though he usually works with the moving image, Sam is currently exploring the knitting machine as a tool for working with digital images and animation. He is also a co-director of Re-Dock, a multimedia arts collective working with people, art and technology. As a freelance creative who lacks a regular '9 to 5' structure, Sam often finds himself working when he should be resting, or engaging in digital recreation under the spurious justification that it

is his 'work'.
www.smeech.co.uk
www.re-dock.org

Molleindustria

(soft industry/soft factory) is a project of the reappropriation of video games, a call for the radicalisation of popular culture and an independent game developer. Since 2003 we produced homeopathic remedies to the idiocy of mainstream entertainment in the form of free, short-form, online games. Our products range from satirical business simulations (McDonald's video game, Oiligarchy) to meditations on labour and alienation (Every Day the Same Dream, Tuboflex), from playable theories (the Free Culture Game, Leaky World) to politically incorrect pseudo-games (Orgasm Simulator, Operation: Pedopriest). Molleindustria obtained extensive media coverage and critical acclaim while hopping between digital art, academia, game design, media activism and Internet folk art.

Aily Nash

is a curator and writer. She has curated programmes and exhibitions for MoMA PS1 (NYC), BAM/Brooklyn Academy of Music (NYC), Anthology Film Archives (NYC), Light Cone's Scratch Expanded (Paris), Northwest Film Center (Portland), Image Forum (Tokyo), Echo Park Film Center (Los Angeles), Art Cinema OFFoff (Ghent) and others. Recent exhibitions include *Image Employment* for MoMA PS1 and *To Look Is to Labor* for CCS Bard/Basilica Hudson. Her writing has appeared in *The Brooklyn Rail*, Artforum. com, *Film Comment*, *Kaleidoscope*, *de Filmkrant* and elsewhere. Nash curates films and moving images for Basilica Hudson, and is an editor of a film criticism programme at the Berlinale Film Festival. She is based in New York.

Stephanie Rothenberg
is an interdisciplinary artist
who engages participatory
performance, installation
and networked media to
create provocative public
interactions. Straddling
the real and the virtual, her
work investigates new mod-
els of global, outsourced
labour and the power
dynamics between contem-
porary visions of utopian
urbanisation and real world
economic, political and
environmental factors. She
has exhibited internation-
ally in venues such as the
Sundance Film Festival,
MASS MoCA, LABoral Art
Center, Transmediale, Zero1
Biennial, New York Hall of
Science and the Whitney
Museum Artport. She is
a recipient of numerous
awards, most recently from
the Harpo Foundation and
Creative Capital, and has
participated in residencies
at Eyebeam and Free103
Wave Farm among others.
Her work has been widely
reviewed, including in
Artforum, *Artnet*,
The Brooklyn Rail and

Hyperallergic. She is
Associate Professor in
the Department of Visual
Studies at SUNY Buffalo
where she teaches courses
in design and emerging
practices. www.stephani-
erothenberg.com

Mari Velonaki
has worked as an artist
in the field of interactive
installation art since 1997.
She has created interactive
installations that incorporate
movement, speech, touch,
breath and electrostatic
charge. In 2003 Mari's prac-
tice expanded to robotics,
when she initiated and led a
major Australian Research
Council project, 'Fish–Bird'
2004–2007, in collabora-
tion with roboticists at the
Australian Centre for Field
Robotics.
In 2006 she co-founded,
with David Rye, the Centre
for Social Robotics, a
centre dedicated to inter-
disciplinary research. In
2007 Mari was awarded
an Australia Council for the
Arts Visual Arts Fellowship
and in 2009 an Australia

Research Council Queen
Elizabeth II Fellowship
(2009–13). Mari is currently
an associate professor and
the director of the Crea-
tive Robotics Lab at NIEA,
COFA, UNSW. Mari's work
has been widely exhibited.

Oliver Walker
born in Liverpool, 1980,
studied Fine Art in Bristol
and received an MA in 'Art
in Context' from the UdK
Berlin (University of the
Arts). He uses live art, in-
terventions and new media
to investigate social and
political systems. Criticism,
humour and innovations are
used to analyse and partly
reconfigure these systems.
His 'Mr Democracy' project
(2008) saw the production
of a written constitution for
the UK outsourced to China,
and was presented in the
form of 1000 speaking dolls
and a three-screen video
installation documenting the
entire production process.
In 'Bringing the Market
Home' (2009) an African
financial index was used to
control a lighting circuit in a

museum in Berlin, establishing a physical connection between the trading actions in finance markets in some parts of the world, and the consequences in everyday situations in others. He has been living and working in Berlin since 2006.

Andrew Norman Wilson

has in the past year participated in *Image Employment* at MoMA PS1, *To Look is To Labor* through CCS Bard/ Basilica Hudson with Harun Farocki and Lucy Raven, Palazzo Peckham at the 55th Venice Biennale, Art Basel with Art Metropole, and group shows at Betonsalon in Paris, Steve Turner Contemporary in Los Angeles, and Carroll/ Fletcher in London. He was recently an artist in residence at Impakt in Utrecht and at the Headlands Center. His work has been featured in *Aperture, Artforum*, DIS magazine and Tank magazine. Wilson currently lives and works in New York.

Inari Wishiki

has been trying to make life easier for people who are trying to live hard. With IN-ARI NOODLE (2010), Inari attempted to make a platform on which artists can earn money without their art practice being interrupted. The idea was if you have to do certain things to earn money, for example working in a noodle bar, could it not be sheer fun? With INARI CARD (2011), Inari made a system in which people living true to their heart are financially treated better. He thought it is strange that everyone has to pay the same price for everything from food to bus fees and so wanted to fix that in his own way. With INARI TRADING CARD (2012), Inari documented the way essential workers function as a social infrastructure. He found that money was naturally following those workers according to their essential motions, unlike that of workers who seek after money.
inarishop.tumblr.com

Artist Credits

Gregory Barsamian (US)
Die Falle (The Trap), 1998
Kinetic sculpture
(fabric, acrylic paint,
urethane foam, steel, motor,
strobe light)
Courtesy of the artist and
Kinetica Museum

Revital Cohen
and Tuur Van Balen (UK)
75 Watt, 2013
HD video with sound,
16 min; 12 bespoke objects
(resin, aluminium, electronics)
Choreography:
Alexander Whitley
Film production: Siya Chen
Commissioned by FACT,
Flemish Authorities,
Ask4Me Group, Zhongshan
City White Horse Electric
Company, V2_Institute for
the Unstable Media,
and workspacebrussels
Courtesy of the artists

Jeff Crouse and Stephanie
Rothenberg (US)
Laborers of Love/LOL,
2011–13
HD video with sound, 2:13
min; website
Courtesy of the artists

Electroboutique:
Aristarkh Chernyshev
and Alexei Shulgin (UK)
iPaw, 2011
Kinetic and electronic
sculpture (electric motor
drive, cast plastic,
polyuretane foam, synthetic
fur, polyurethane, silicone,
aluminium, steel, computer,
custom electronics)
Courtesy of the artist and
Kinetica Museum

Blake Fall-Conroy (UK)
Minimum Wage Machine,
2008–ongoing
Kinetic sculpture (custom

electronics, change sorter,
wood, plexiglass, motor,
misc. hardware, pennies)
Refabricated at FACT
in collaboration with DoES
Liverpool and Freehand
Courtesy of the artist

Harun Farocki
(Germany)
A New Product, 2012
Single-channel video
with sound, 37 min
Courtesy of the artist
and Harun Farocki
Filmproduktion

Harun Farocki
(Germany)
*Workers Leaving
the Factory*, 1995
Single-channel video
with sound, 36 min
Courtesy of the artist
and Harun Farocki
Filmproduktion

Ellie Harrison (UK)
Timelines, 2006
Vinyl data visualisation
from Excel spreadsheet.
The Timelines project
was undertaken as part of
Part-time – a 'residency
programme' conceived
by Liverpool-based artist
Steven Renshaw.
Courtesy of the artist

Sam Meech (UK)
Punchcard Economy, 2013
Machine-knitted banner
Commissioned by
FACT with support from
Arts Council England
Courtesy of the artist

Molleindustria (Italy/US)
*To Build a Better
Mousetrap*, 2013
Digital game
Courtesy of the artist

Mari Velonaki
(Australia)
Diamandini, 2011–13
Interactive robot
Courtesy of the artist with
support from Australia
Council for the Arts,
Creative Robotics Lab,
NIEA/COFA the

University of New South
Wales, Australia Research
Council, Centre for Social
Robotics/Australian Centre
for Field Robotics,
University of Sydney
Oliver Walker
(UK/Germany)
One Pound, 2013
Six-channel HD video,
various durations
Commissioned by FACT
Supported by the National
Lottery through Arts
Council England
Courtesy of the artist

Andrew Norman Wilson
and Aily Nash (US)
*The Dream Factory
(Parts I and II)* includes:
The Trainee, Pilvi Takala,
2008 (13 min)
Stealing Beauty, Guy
Ben-Ner, 2007 (18 min)
People's Passion, Lifestyle
Beautiful Wine, Gigantic
Glass Towers,
All Surrounded by Water,
Neil Beloufa, 2011 (10 min)
Strategies, Harm van den
Dorpel, 2011 (5 min)
Green Screen Refrigerator,
Mark Leckey, 2010 (17 min)
Strike, Hito Steyerl,

2010 (30 sec)
Curated selection of
videos of various lengths
with sound
Courtesy of the artists and
curators
Andrew Norman Wilson
(US)
*Workers Leaving the
Googleplex*, 2009–11
HD video with sound, 11 min
Courtesy of the artist

Credits

This publication is published on the
occasion of the exhibition
Time & Motion: Redefining Working Life
12 December 2013 – 9 March 2014
FACT, Foundation for Art and Creative
Technology, Liverpool
Produced by FACT in association with the
Royal College of Art
Artistic Director: Mike Stubbs

Exhibition

Curator: Mike Stubbs
Curatorial Advisor: Jeremy Myerson
Curatorial Assistant: Emily Gee
Programme Producer: Ana Botella
Exhibition design: Alon Meron
Graphic Design: Giulia Garbin
and Jack Llewellyn
Artists: Gregory Barsamian, Electroboutique
(Alexei Shulgin & Aristarkh Chernyshev),
Blake Fall-Conroy, Harun Farocki,
Ellie Harrison, Adrian McEwen, Sam
Meech, Molleindustria, Andrew Norman
Wilson & Aily Nash, Stephanie Rothenberg
& Jeff Crouse, Mari Velonaki, Cohen Van
Balen (Revital Cohen and Tuur Van Balen),
Oliver Walker, Inari Wishiki
The Creative Exchange research team:
Ben Dalton, John Fass, Veronica Ranner;
coordinator: Bronac Ferran
Lenders: The artists, Gregory Barsamian
courtesy of Kinetica Museum
Supported by: Arts Council England, Arts
and Humanities Research Council, Australia
Council for the Arts, Creative Robotics Lab,
NIEA/COFA the University of New South
Wales, Australia Research Council, Centre
for Social Robotics / Australian Centre
for Field Robotics, University of Sydney
With thanks to the artists, contributors and
all FACT and RCA staff.

Publication

Editors: Emily Gee and Jeremy Myerson
Original Design: Giulia Garbin
and Jack Llewellyn
Typesetting: Giulia Garbin
Contributors: Ben Dalton & John Fass,
Harun Farocki, Bronac Ferran, Christopher
Frayling, Richard Koeck, Jeremy Myerson
& Philip Ross, Paolo Pedericini,
Mike Stubbs, Georgina Voss

First published 2013 by
Liverpool University Press
4 Cambridge Street
Liverpool L69 7ZU
and FACT
88 Wood Street
Liverpool L1 4DQ

ISBN 978-1-84631-966-2

Printed and bound by Gutenberg Press